BASEBALL IN TRENTON

BASEBALL IN TRENTON

Tom McCarthy

Copyright © 2003 by Tom McCarthy.
ISBN 0-7385-1310-5

First printed in 2003.

Published by Arcadia Publishing,
an imprint of Tempus Publishing Inc.
2A Cumberland Street
Charleston, SC 29401

Printed in Great Britain.

Library of Congress Catalog Card Number: 2003107573

For all general information, contact Arcadia Publishing:
Telephone 843-853-2070
Fax 843-853-0044
E-mail sales@arcadiapublishing.com

For customer service and orders:
Toll-free 1-888-313-2665

Visit us on the Internet at www.arcadiapublishing.com.

Contents

Acknowledgments		6
Introduction		7
1.	The First Half of the 20th Century	9
2.	Baseball Returns to Trenton	33
3.	Trenton Changes its Socks to Red	59
4.	The Yankees are Coming	117

ACKNOWLEDGMENTS

This is the part of the book that I looked forward to writing from the beginning. First and foremost, the proceeds from this book will go to the Thunder's Grand Slam Foundation. The program is near to my heart because it was one that I began during my days with the Thunder, and it has evolved to include the Lakewood Blue Claws, the Single-A affiliate of the Philadelphia Phillies.

I also have to thank several individuals who made my work on this book so enjoyable. If there was a second name to put on this book, it would be Dave Schofield, the talented team photographer for the Thunder, who brought an energy to the franchise the first day I met and hired him on a January morning in 1994. More than 150 photographs for this book were donated by Dave, and his work is going to be a lasting and important timeline for the history of baseball in Trenton.

Another big thank-you has to go out to my good friend Barry Levy, an unknown in the minor-league baseball world but a guy who has been a great sounding board during this project. He scanned photographs and answered questions that I did not even know were in me when this project began. I also have to thank my former college professor Dr. Robert Cole of the College of New Jersey. I was in search of a path and a good pep talk when this began, and he was the right person to provide both.

One of the lasting memories I have with this project is meeting Ruth Cunningham, a treasure of knowledge on the Giants, whose husband, Mo, was a force for the team during the late 1940s and in 1950. The conversations with Ruth were not only enlightening, but the photographs and scrapbooks she provided were an immeasurable help. I would also like to thank Richard Kitchen, whose website, mercerbaseball.com, was a giant help in the genesis of my research. I have to credit the work of Bill Cook and Dan Loney of the Trenton Thunder; Rick Suta of White Eagle Printing; Wendy Nardi, the keeper of history at the Trenton Public Library; George Case III, whose dad is the greatest player to come out of Trenton; and my former employers, the *Times* of Trenton, in particular sports editor Jim Gauger and Diana Groden, who is in charge of the library for the *Times*. I also would like to thank Rick Freeman, John Nalbone, and Chris Edwards, and those who wrote for the *Trentonian*, in particular Larry O'Rourke. I want to thank the good folks at Arcadia Publishing, in particular Tiffany Howe and Brendan Cornwell, who came up with the fabulous design of the cover.

There are two groups that I have saved for last. One is my extended family at the Thunder, including Wayne Hodes, Brian Mahoney, Eric Lipsman (do not ever change), Todd Pae, Rick Brenner, and Geoff Brown. Along with myself, these are the original members of the Thunder front office, and each had a tremendous impact on the return of baseball to Trenton. None of us would have ever been involved in this amazing minor-league adventure if not for the ownership group that has been such a big part of my life. I hope people in Trenton understand how much Joe Finley, Joe Caruso, and Joe Plumeri have done for the community over the years. They, along with the late Sam Plumeri and Jim Maloney, genuinely believe in giving back, whether it is with their RBI program or all of the community initiatives that have been started under their guidance. Each of them should be applauded.

Finally, I would like to thank my wife Meg and my kids, Patrick, Tommy (I told you I would mention you), Maggie, and Kerri. This was a project that took a lot of time away from them as I searched for one more dream to check off my list, and I appreciate their understanding.

INTRODUCTION

The sun, with intensity that was worn down from a long, hot summer at the Jersey Shore, broke through the clouds on that September afternoon, just in time for the capital of New Jersey to throw its glove back on the diamond of professional baseball. For several months leading up to that 1993 press conference, there had been extensive discussions concerning a minor-league baseball team coming to New Jersey from Canada. For many, it was just talk. For others, it was a topic that warranted extensive debate. Could Trenton, which was just 50 minutes from Philadelphia and an hour from New York, house a professional baseball team? The debate raged on for days, weeks, and even months. Many involved in the sports industry in Mercer County were skeptical. They did not think anyone would come to Trenton for a baseball game. True, the history was there, but history is difficult to repeat 44 years later, as the last time Trenton had an active professional baseball club that many years prior.

Yet, for at least that afternoon, in front of a vacant lot outside the Riverview Executive Plaza in South Trenton, the outward smiles and obvious confidence of Mercer County executive Robert Prunetti, Mayor Doug Palmer of Trenton, a host of Trenton city councilmen, and Governor Jim Florio of New Jersey were sprinkled over a modest crowd of baseball enthusiasts. Baseball was returning to Trenton after an absence of more than four decades.

The idea of bringing a minor-league franchise to Trenton was new to this generation, but for the two generations before, baseball in Trenton was a way of life. According to *The Encyclopedia of Minor League Baseball,* Trenton's relationship with professional baseball began in 1883 with a team in the Interstate League. That team, managed by Albert Douress and later Joseph Simmons, finished the 72-game schedule with a 34-38 record, 10 games behind the Brooklyn Grays. A pitcher by the name of John Harkins led the league in strikeouts with 213. That was followed by two seasons in the Eastern League, 1884 and 1885. The 1884 edition of the Trenton Trentonians, managed by Patrick Powers, won the league championship by four games over the Lancaster Ironsides, marking the first championship for a Trenton franchise. The following year, the team finished 25.5 games behind first place. Powers was again in the baseball spotlight in September 1901, when the National Association, the governing body of Minor League Baseball, was formed in Chicago, and he was elected president. Powers lasted as president until 1909.

Trenton's participation in professional baseball ended when the Trentonians moved to Jersey City for the 1886 season, but the city's love for baseball was still growing. Before the turn of the 20th century, Trenton was the home of the Cuban Giants, a talented Negro League squad that played in the Middle States League. According to the book *The Jersey Game,* the team played some of its home games in other New Jersey cities, mostly Hoboken.

Professional baseball was dormant in Trenton until 1907, when the Trenton Tigers formed and played in the Interstate League. The team, with no affiliation, played in the Tri-State League from 1907 until 1914 and won the league title in 1911. That year, John Davis led the league with a .363 batting average. The following year, Charles Johnson led the Tigers with a .403 batting average. He is still the only Trenton player to eclipse a .400 batting average.

When the team folded at the end of the 1914 season, Trenton remained quiet in the professional ranks until Clifford Case, the owner of Case's Pork Roll (Pork Pack), in Trenton and owner Joe Cambria brought the York White Roses to the city in July 1936. The team played its games at Dunn Field, the former field of Trenton Catholic High School. Cambria brought everything, including the lights, to Dunn Field and, under the guidance of Clifford Case, brought minor-league baseball back to Trenton.

The Trenton Senators played in the New York-Penn League for the remainder of the 1936 season and all of the 1937 season. The 1937 team featured Spencer Abbott as the manager (he arrived midway through the year) and a young George Case, the nephew of Clifford Case, as one of the outfielders. Case went on to play in the major leagues for more than a decade. In 1938, the Senators moved to the Eastern League, where they stayed for a year before moving back to the Interstate League. By now, they were managed by Hall of Fame player Goose Goslin, who was named Manager of the Year in the Interstate League in 1939. Although not affiliated with a major-league team, the Washington Senators were known to take a few of the Trenton players, including George Case.

The 1941 season marked the final year of independence for the Trenton franchise. With World War II underway, Trenton began an affiliation with the Philadelphia Phillies in 1942 and, the following year, the team changed its name to the Packers, in honor of Clifford Case's pork roll company. By 1943, one of the greatest players to dawn a Trenton uniform, Del Ennis, was part of the club and on his way to a great career with the Phillies. Next up for Trenton was the Spartans in 1944 and 1945, a Brooklyn Dodgers affiliate that featured eventual Hall of Fame manager Walter Alston as its skipper. As the war ended, more minor-league teams popped up around the country and, during what was called the start of the "Golden Years" of minor-league baseball, the New York Giants began a five-year affiliation with Trenton that produced major leaguers Jack Maguire, Bobby Hoffman, Hal Bamberger, Bill Jennings, and Willie Mays.

The surprising part of Trenton's baseball history came in 1951 when Dunn Field was dormant, without a team for the first time in 15 years. True, there were some great amateur teams in Trenton and Mercer County during of the 1960s, but there was a strange void in the city from 1951 until the spring of 1994 when the Trenton Thunder, then the Double-A affiliate of the Detroit Tigers, arrived to play in the Eastern League. The owners of the Thunder knew they would be a success, but not to the lengths that the franchise has gone. Following a delay of the stadium in 1994, the Thunder have never looked back, establishing themselves as one of the most consistent franchises in minor-league baseball. They have drawn more than four million fans in 10 years—an average in excess of 400,000 a season—and have made a lasting impact on the Trenton community.

These photographs do not tell the entire story of Trenton's baseball history. That history, particularly in the 1880s and the early 1900s, is lengthy in its own right, and few clear photographs of that time period remain. This book recognizes the many people who helped put Trenton on the baseball map, like Clifford and George Case, Joe Cambria, Joseph Plumeri and his son Sam and grandson Joseph, Joe Finley, Joe Caruso, Jim Maloney, Robert Prunetti, and Doug Palmer. The latter eight people proved that history is difficult to repeat but is fun when you repeat it and exceed its great expectations.

—Tom McCarthy

One
THE FIRST HALF OF THE 20TH CENTURY

There are a number of fields that have been used for baseball around Mercer County, including Hetzel and Wetzel Fields, as well as Moody Park and the fields at Mercer County Park; but the field that was the home for the Trenton farm teams from 1936 until 1950 was Dunn Field. This photograph gives a perfect glimpse of the playing field from behind home plate with all of the outfield billboards showing as clear as day. Owner Joe Cambria, along with local businessman Clifford Case, had the ballpark refurbished when the Senators arrived in July 1936. From all reports, the capacity of the stadium was approximately 3,500 and, for many years, the fans came to see their teams. In 1947, the Giants just missed the 100,000 mark in overall attendance, as they won their first divisional title since moving to Trenton. Dunn Field is credited with being the home to many great ballplayers, including Del Ennis, Walter Alston, Mo Cunningham, and, the greatest of them all, outfielder Willie Mays. (Courtesy the Trenton Public Library.)

When the Senators came to Trenton in 1936, they needed a place to play, and Dunn Field was given that distinction. The former high school field needed to be refurbished, and Clifford Case (left) and Joe Plumeri (right), who helped bring the Senators to Trenton, are seen here as the grandstand is being built at Dunn Field. Plumeri was the vice president of the Trenton Baseball Club, and Case, who is credited with bringing baseball back to Trenton, was the president. (Courtesy Richard Kitchen.)

Manager Spencer Abbott took over the Senators in 1937 and led them to a 54-80 record. In 1938, the league name changed to the Eastern League, and although their record of 62-77 was better than in 1937, the Senators still finished second to last, 24 games out of first place. Abbott, who managed in the minor leagues for 34 years, was known as the Connie Mack of the minor leagues because of his longevity. Here, Abbott got a chance to chat with the legendary Connie Mack at Dunn Field. (Courtesy George Case III.)

Goose Goslin was one of the most recognized players in major-league baseball for nearly two decades. Although his major-league career took him to the Hall of Fame, few know that he continued to play with the Senators as the team's manager from 1939 to 1941. The club finished at 51-51 in 1939, and he was the Interstate League Manager of the Year. He followed that up with a 69-54 record in 1940 and a 68-57 record in 1941. During the 1941 season, he shared the duties with Gerald Hannahoe. According to the Interstate League record books, Goslin was the first manager to be ejected from a league game in 1939. (Courtesy the *Times* of Trenton.)

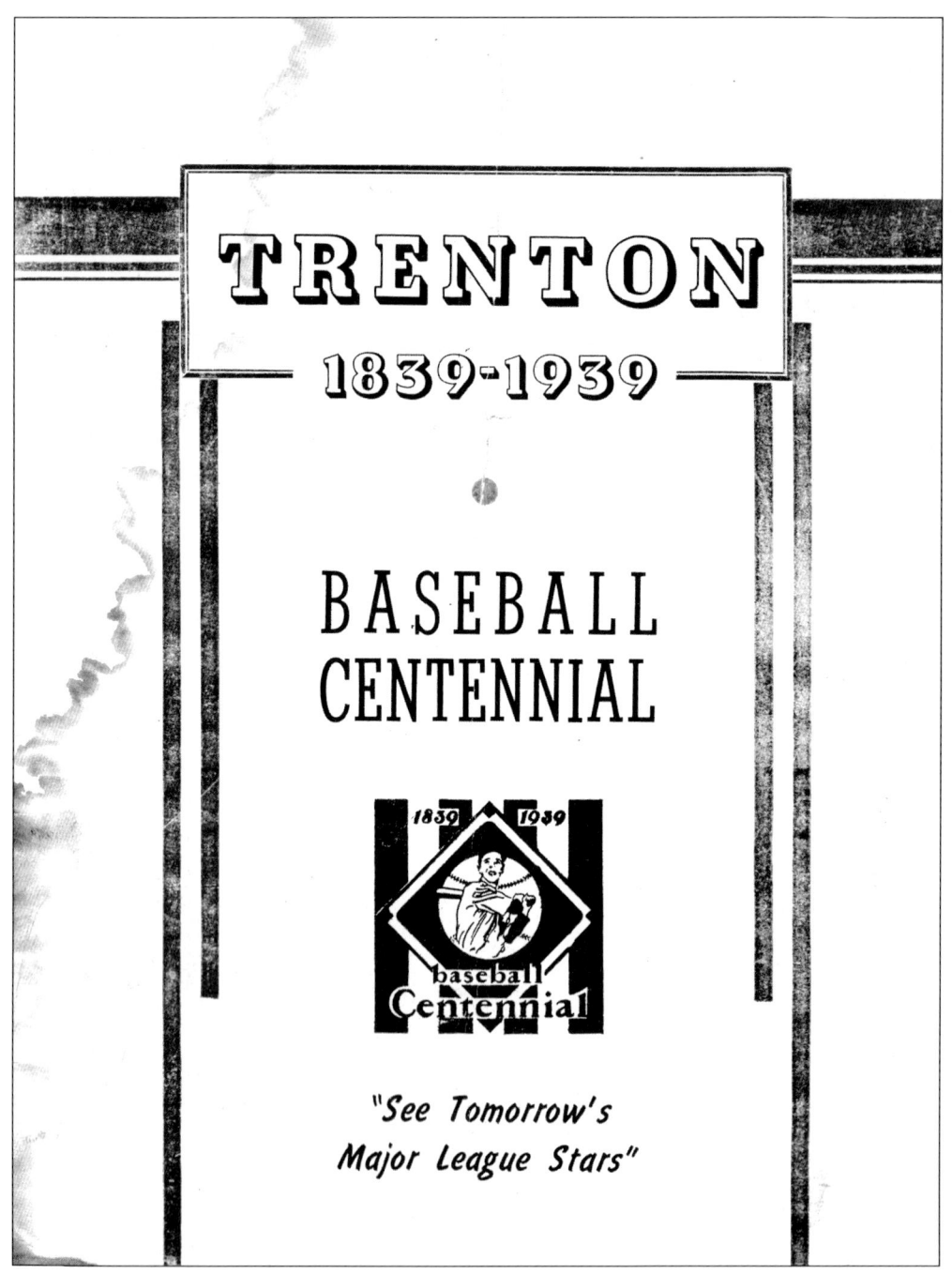

The 1939 Trenton Senators finished the four-team Interstate League regular season tied for second place with the Sunbury Senators. The team lost a chance to go to the playoffs when Sunbury defeated them in a one-game playoff. The Senators were led by second baseman Charles Budd and pitcher Russ Bailey, who led the league with a 3.11 earned-run average (ERA). They were an independent team in 1939. This season began an 11-year run for the city of Trenton in the Interstate League. (Courtesy Richard Kitchen.)

The 1939 season marked the first for the Trenton franchise in the Interstate League. This team photograph shows manager Goose Goslin (bottom row, third from the right) with his club. The Senators, along with the rest of the baseball world, were celebrating the 100th anniversary of the sport. The team was sponsored by Cliff Case's pork roll company. (Courtesy Richard Kitchen.)

The dais at the 1939 Trenton sports dinner shows the influence Trenton had on the professional baseball world. Seen here are, from left to right, the following: (front row) Jimmie Foxx, Johnny VanderMeer, Roy Mack, Stuart Hill, Cliff Case (owner of the Senators), and Stuart O'Donnell; (back row) unidentified, Ira Thomas (scout for the Philadelphia A's), By Saam (A's Hall of Fame broadcaster), unidentified, unidentified, George Case, Charles Hargreaves (Brooklyn Dodgers), Frank Spair (business manager of the Trenton Senators), and unidentified. (Courtesy Richard Kitchen.)

Joe Cambria (left) visits with former Senators star and Washington Senators base stealer George Case following Case's career with Trenton. Cambria brought the franchise to Trenton from York, Pennsylvania, in the middle of the 1936 season and remained the owner until the 1938 season came to a close. Cambria brought the team, but Case's uncle Clifford, owner of Cliff Case's pork roll company, provided the field and the initial backing. (Courtesy Richard Kitchen.)

Trenton native George Case is probably the most storied baseball player to come out of the city. Case not only played for the Senators, but it was his uncle Cliff who coaxed Joe Cambria into bringing the franchise to Trenton because it would feature his nephew. Case played parts of two seasons for the Senators, 1936 and 1937, before he was signed to a big-league contract with the Washington Senators. In 11 years with Washington and Cleveland, Case stole 349 bases and had a .282 batting average. He later returned to Trenton to run a sporting goods store. (Courtesy Richard Kitchen.)

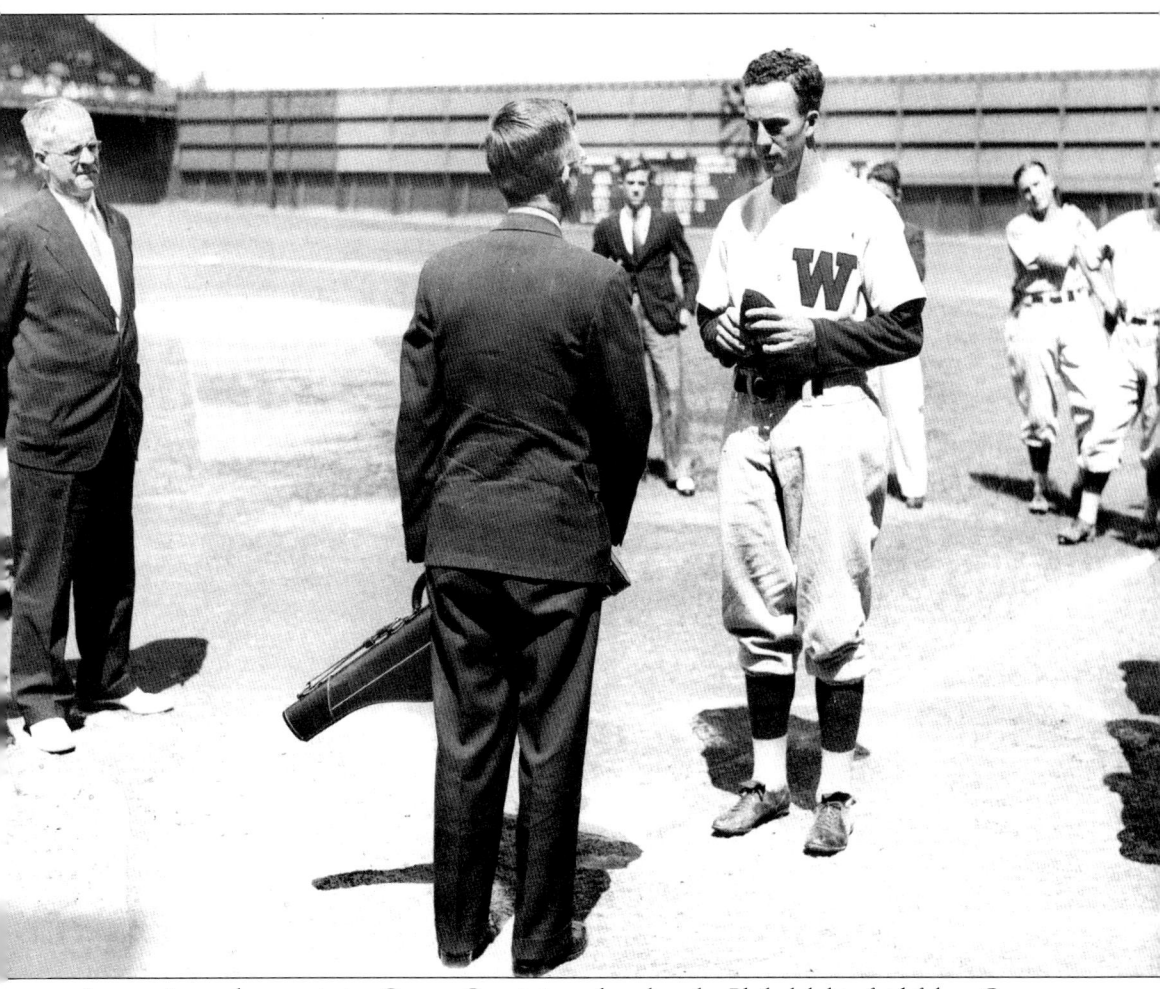

A tentative and appreciative George Case is introduced to the Philadelphia faithful on George Case Day at Shibe Park, the home of the A's and Phillies. The relationship between Trenton and Philadelphia seemed to be strong because Connie Mack, then the manager of the A's, often spent time in Trenton at Dunn Field looking at prospects. Here, a prospect he saw an awful lot, receives special recognition from delegates who came from Trenton. George Case signed with the Senators and was brought up to the big leagues in September 1937 and hit .289 in 22 games. Durning his first full season with Washington in 1938, Case, who passed away in 1989, hit .305 with two home runs and 40 RBIs; but he scored 69 runs and stole 11 bases. He went on to lead the league in stolen bases six times, including five years in a row from 1938 to 1943. He also scored more than 100 runs four times. In 1943, he hit .294 with 180 hits, 102 runs, and had a career-high 61 stolen bases.

ANDREW JACKSON CASE, left, and W. Clifford Case, above, were two of founder's nine children.

she wrote, "but we do miss a few of the things our home town is noted for —particularly Pork Roll. I am hoping to give a picnic and introduce Pork Roll to these people out here who eat only hamburgers and Tacos."

Another Trenton woman now living in Glendale, California who had just celebrated her 83rd birthday anniversary, also wrote the other day asking for another shipment of Pork Roll. A supply sent earlier, she advised, had been distributed among her family as birthday gifts. "All this family are native Trentonians," she added, "and sure miss the Pork Roll."

There are scores of similar letters in the files of the Case Company and hardly a day goes by, advises Clifford L. Case, company president and grandson of the founder, but that the shipping department isn't sending out a supply of this tasty meat product to a former resident who remembers New Jersey's capital city best as the place where Pork Roll is processed. With each order also goes a descriptive booklet prepared by the company's home economist showing the many different ways in which Pork Roll may be served.

Sold in Six States

For people living in the six-state area where Case's Pork Roll is sold in retail shops, obtaining a fresh supply of the product presents no problem. And rising sales charts in the Case Company offices show that they're buying more of it than ever before. The company's eight refrigerated trucks fan out daily from the Trenton plant to deliver Pork Roll and two other products, Case's Sausage and Smoked Pork Shoulder Butts, to stores throughout New Jersey and neighboring points. On the longer hauls, shipments are made in refrigerated trucks of the various common carrier lines.

This delivery system is quite a change from the horse and wagon that George Washington Case used when he began selling his Pork Roll back in 1870. What hasn't changed is the basic recipe which Mr. Case originated for grinding, seasoning and curing the pork shoulder meat from which Pork Roll is made. The formula is a closely-guarded Case family secret and was developed by Mr. Case only after long experimentation on his Belle Mead farm where he raised his own hogs. At the start he placed his pork preparation in green corn husks, tied the husks at the top and the hung them in the smokehouse. The corn husks

YOUNGEST CHILD of large family, famed major league star, George W. Case II is now in Hawaii.

TRENTON

As it turns out, the Case family was more than instrumental in bringing professional baseball back to Trenton. In this magazine article, the three Case family members, Andrew Jackson Case (top left), Clifford Case (right), and George Case (sliding bottom left), are talked about at length. Although George is recognized as the greatest position player to come out of Trenton, with Al Downing as the greatest pitcher, his uncle Cliff and Andrew also played minor-league baseball, but outside New Jersey's capital. When Cliff brought the York franchise to Trenton in the middle of the 1936 season, the promise was that young George would play for the team. He did for the second half of 1936 and in 1937, before he was bought by the Washington Senators.

The 1942–1943 Trenton franchise was affiliated with the Philadelphia Phillies. Although the Phillies were struggling, they did provide some stability for the Trenton Packers, named for Cliff Case's pork roll company in 1942, when the affiliation with the Phillies began. Not only that, but this team photograph shows off one of the greatest sluggers in Trenton's history: future big-leaguer Del Ennis (top row, third from the left). Also featured in the photograph is George Hennessey (bottom row, third from the left), who pitched two shutouts in one day against Hagerstown on July 18, 1943. The team's name was changed to the Packers when the Phillies became their affiliate in 1942. (Courtesy Richard Kitchen.)

Del Ennis enjoyed a fantastic big-league career with the Phillies and the Cardinals. He hit .284 with 288 home runs and 1,284 RBIs in his career, and many people feel he should be sitting alongside fellow Phillies outfielder Richie Ashburn in the Hall of Fame. Ennis played one season in Trenton in 1943 and hit .346 with 37 doubles, 16 triples, and 18 home runs. His 18 home runs were a record for several years in Trenton. Not only that, but his .347 batting average is still among the top ten in Trenton minor-league history. (Courtesy the Philadelphia Phillies.)

Trenton had its share of Hall of Famers, including former Trenton Spartans and Packers manager Walter Alston. Alston (seen here with a Spartans uniform) was hired by Branch Rickey to be the player-manager of the Trenton franchise in 1944 and lasted for two seasons. In 1944 and 1945, the franchise was affiliated with the Brooklyn Dodgers. In 1944, Alston managed the Packers to a less than .500 record, but he batted over .340. In 1945, with the team's name changed to the Spartans, Alston's team finished above .500 and in third place in the Interstate League. His first two years in Trenton marked the start of a very successful 33-year managerial career that saw him win 2,040 games and seven pennants. He was elected to the National Baseball Hall of Fame in 1983. (Courtesy the *Times* of Trenton.)

When the New York Giants bought the Trenton franchise and placed a team at Dunn Field, the listed president of the club was former left-hander Carl Hubbell, whose claim to fame, among other things, was that he struck out Babe Ruth, Lou Gehrig, Jimmie Foxx, Al Simmons, and Joe Cronin in succession during the 1934 All-Star Game. He was the National League Most Valuable Player twice and the man who assigned players to Trenton. He helped to organize the 1946 team featuring Jack Maguire, who played one season with the New York Giants.

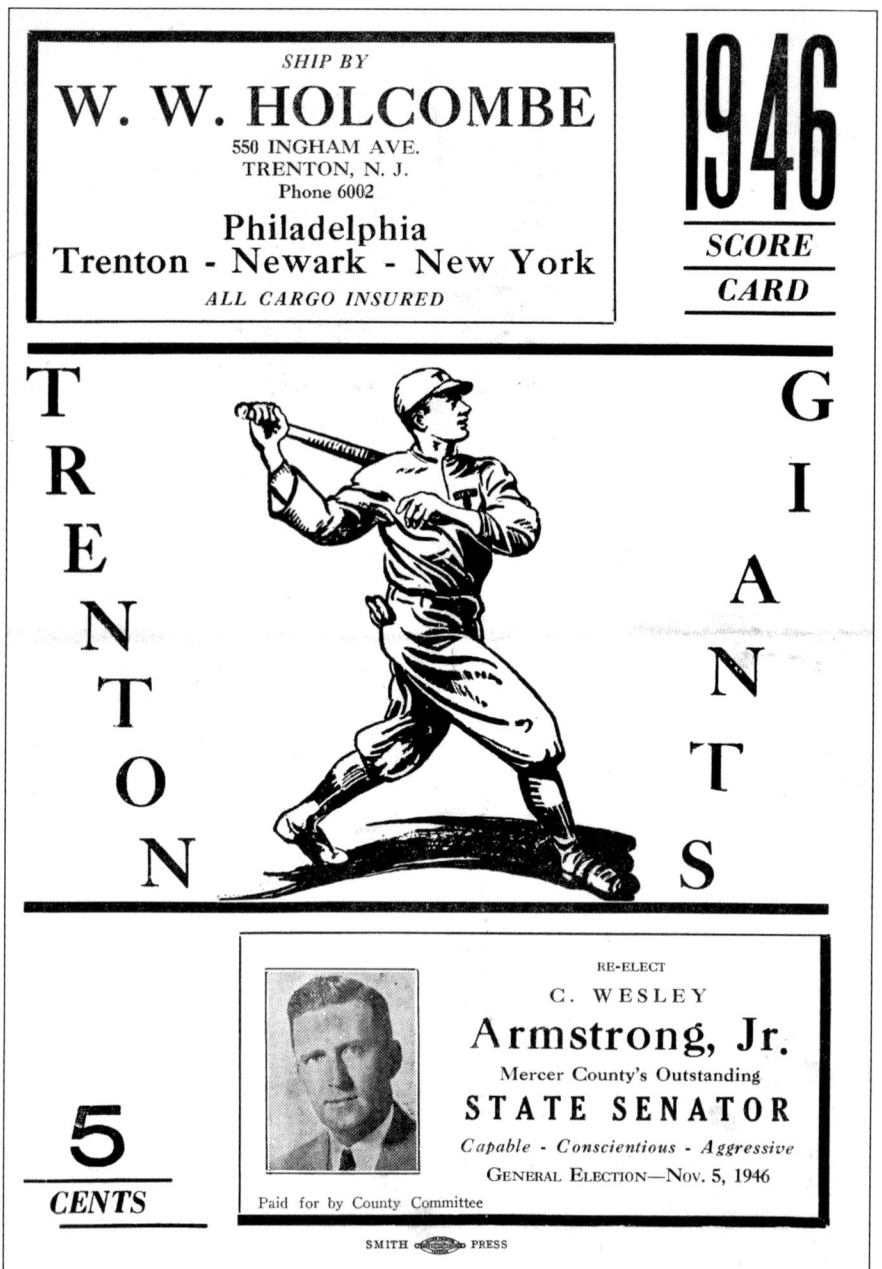

The 1946 season marked the first year that the New York Giants had a club in Trenton. The Giants, like the Spartans, Packers, and Senators before them, played their games at Dunn Field. In 1946, the team finished in seventh place under the direction of Earl Wolgamot. Wolgamot led his team to a 60-78 record, finishing 26 games behind the first-place Wilmington Blue Rocks. The 1946 season was big for professional baseball because it marked the first season for Jackie Robinson, who was playing for Montreal in the International League. As for the Trenton franchise, the only real bright spot for the team came on June 10, when Walter Konikowski tossed a seven-inning no-hitter against the Harrisburg Senators. The 1946 season would be Wolgamot's only in Trenton. In 1947, Tommy Heath would take over for a two-year run.

Harold "Bus" Saidt, a Trenton treasure through and through, was the Giants announcer from 1947 until the team left in 1950. The games were heard on WBUD in Trenton. He also broadcasted Princeton University football games for WBUD, while working as an accountant for the city during the day. Later, Bus wrote for the *Trentonian* and later the *Times* in Trenton. While at the *Times*, Bus was elected to the writer's wing of the National Baseball Hall of Fame. He was a classic man with a classic style that is still remembered. (Courtesy of the *Times* of Trenton.)

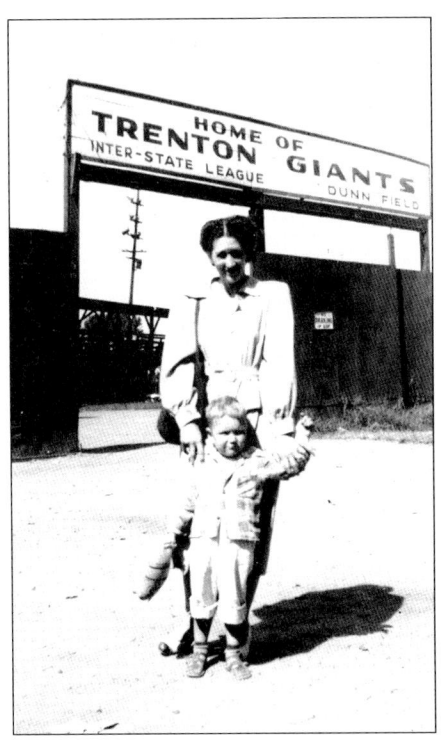

Tommy Heath's wife and child pose in front of a sign at Dunn Field letting everyone know that the facility is the home of the Trenton Giants. The Giants drew 97,389 in 1948, which was fifth in attendance in the Interstate League. (Courtesy Ruth Cunningham.)

The 1948 Trenton Giants were managed for a second straight season by Tommy Heath. After winning 52 of their final 60 games, the Giants won the division championship. They followed that up with this cast of characters, who finished one percentage point behind Wilmington for second place in the regular season with an 83-57 record. In the postseason, though, the Giants defeated Sunbury four games to three and swept York in four games in the championship to win their first Governor's Cup. Heath was named the manager of the year after the 1948 season. Besides the likes of Mo Cunningham (third row, third from the right) and Stan Jok (second row, first from the left), Dave Sayers is also featured (third row, far right). Sayers held the Interstate League record for consecutive scoreless innings, going 37 frames in 1948 from June 29 to July 20. Cunningham and Jok became the first teammates to hit 20 or more home runs each in Interstate League history. (Courtesy Ruth Cunningham.)

Iowa native Mo Cunningham (on the right with teammate Ray Rambin, center, and an unidentified member of the Giants) set the standard for home runs in the Interstate League in 1948 when he connected on 25, breaking Del Ennis's Trenton record of 18. Cunningham played three seasons with the Giants. Following his playing career, Cunningham remained in the area and lived with his wife Ruth in Hamilton, New Jersey. (Courtesy the *Times* of Trenton.)

Named and donated by the former governor of New Jersey, Harold Hoffman, the Governor's Cup is awarded to the champion of the Interstate League. The cup is housed at the Trenton Club, but the championship team received a replica cup that was housed permanently at their facility. The Giants received the Governor's Cup in 1948 and 1949.

According to reports, it was difficult for anyone to replace the affable Tommy Heath as manager of the Trenton Giants. Hugh Poland, seen here at spring training in 1949, had that distinction during the championship run of 1949. Poland was a former high school coach who, along with Heath, was a catcher for the Giants, Reds, Cardinals, and Phillies. (Courtesy Ruth Cunningham.)

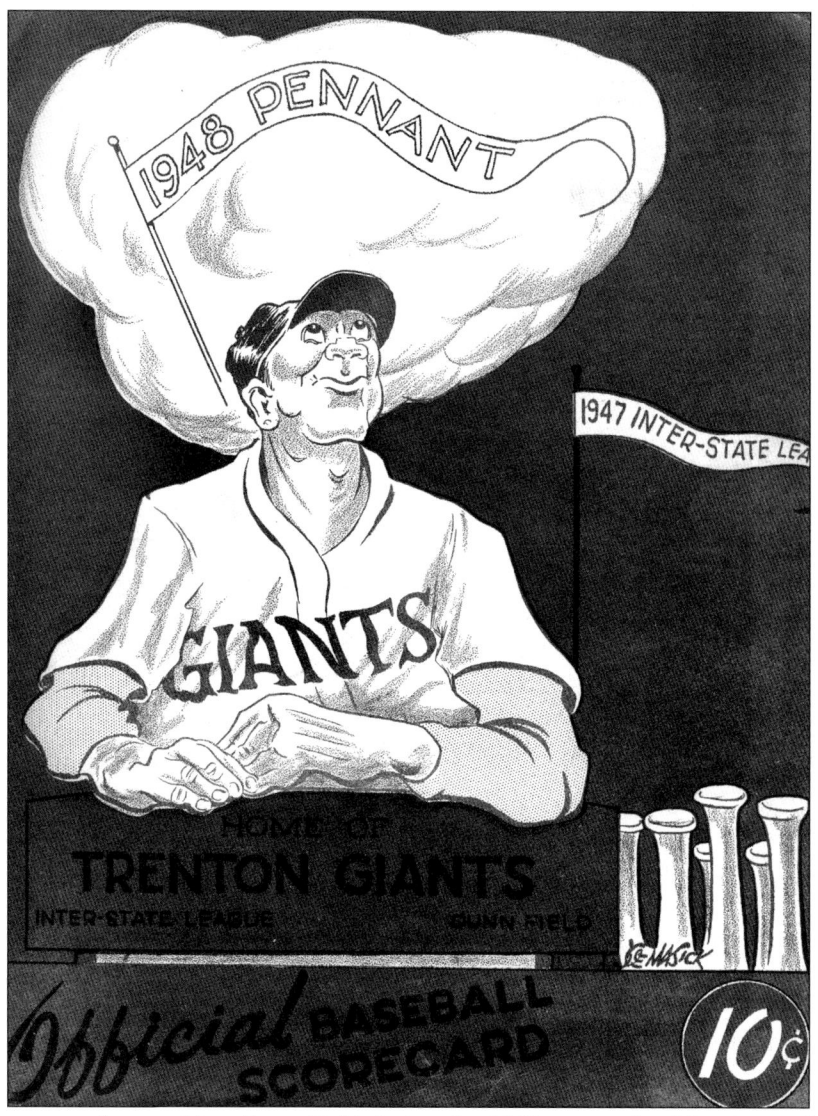

This 10¢ scorecard was sold at Dunn Field during the 1948 season. Joe Masick was the cover artist, and his skills were obvious with each of the covers that were done during the team's years at Dunn Field. This cover depicts the Giants' Interstate League title in 1947. The question during the 1948 season was whether the Giants could go on and win the Governor's Cup. They won the title for first time and did it a second time in 1949. During the 1947 season, the Trenton Giants won their first divisional title, but they failed to win the Governor's Cup when they lost in the playoffs to Allentown four games to two. Right-hander Andy Tomasic was a part of a stellar staff that helped lead the Giants to the title. Tomasic became an all-star after winning 18 games, completing 24 overall, while compiling a 2.48 ERA. "Handy" Andy also set a league record for strikeouts with 278. Also part of that 1947 team was Harold "Bammy" Bamberger, a native of Lebanon, Pennsylvania. Bamberger set an Interstate League record in 1947 with 24 triples. The Giants outfielder also hit .333 that season and helped the Giants to an 88-50 record and a first-place finish. He was selected as a member of the post-season all-star team, joining teammate Andy Tomasic. Bamberger was one of a half dozen Giants to make it to the parent club. He played seven games in 1948 and had one hit. (Courtesy Ruth Cunningham.)

Mo Cunningham (bottom row, first from the left) came back in 1949 and led the league in RBIs with 101, as the Giants once again won the Governor's Cup after finishing in fourth place in the regular season. Cunningham was not the only hitting star on this team. Bill Henry (second row, fourth from the right) led the league in hits with 178 and had the highest batting average with .333. Ray Rambin (top row, third from the left) made the all-star team at third base, as Trenton defeated Harrisburg four games to three in the championship. In the second row, the second player in from the right is Tony West, who threw the first nine inning no-hitter on May 8, 1949, against Sunbury. Trenton won the game 11-0. (Courtesy Ruth Cunningham.)

The Giants spring training was in Sanford, Florida. Here, third baseman Ray Rambin battles the heat while taking some swings. Rambin finished as the top third baseman in 1949 and was the only Giants player to be selected to the post-season all-star team.

After getting past one of their biggest rivals, the Wilmington Blue Rocks, in the opening round of the Interstate League playoffs, the Giants had to defeat third-place Harrisburg in the final in order to win the Governor's Cup in 1949. In this photograph at Dunn Field, Mo Cunningham scores ahead of the tag to give Trenton the lead. The lights were not the best at Dunn Field. In fact, many players said they were like candles. (Courtesy Ruth Cunningham.)

Down in Sanford, Florida, Mo Cunningham (left) and Chick Genovese (right), the new manager of the Trenton Giants, get acquainted. Cunningham clubbed more than 40 home runs during the previous two seasons and was about to shift from center field to left field to make room for rookie Willie Mays. When Cunningham's playing days were over, he retired to Hamilton, New Jersey, and was active in youth baseball and American Legion baseball, while also working for Prudential Insurance for more than two decades. Genovese led the Giants to a 73-65 record their last season in Trenton. (Courtesy Ruth Cunningham.)

The greatest player to ever wear a Trenton uniform was outfielder Willie Mays, who joined Mo Cunningham in the Giants outfield in 1950 at the age of 19. The Giants players, including Cunningham and catcher Len Matte, gave him the nickname "Junior" and helped him along that season; but Mays did not need a lot of help. In 81 games with the Giants, he hit .353 and was on his way to becoming one of the greatest baseball players of all time. At one point in August of that year, he hit over .400. He went on to play in Minneapolis on the Triple-A level before making his major-league debut in 1951. All totaled, Mays hit 660 big-league home runs, collected 3,283 hits, and won one World Series. (Courtesy the Trenton Public Library.)

This 1950 team photograph features Mays (front row, center) with his new teammates. According to Ruth Cunningham, the widow of Giants outfielder Mo Cunningham, the players did their best to shield Mays from the racism that was rampant in the southern part of the league, but, unfortunately, he was often unable to eat with the team on the road and had to stay at separate hotels. Mays later credited Matte and Cunningham for making him feel welcome in Trenton during his stay. The day he arrived in Trenton, he was picked up by radio announcer Bus Saidt and taken to his first game. He was 2-for-4 in his debut with the Giants and was hitting .423 by mid-August. (Courtesy Ruth Cunningham.)

Hitting was Bob Easterbrook's best skill, but during the 1950 season, pitching was as well. A right fielder for most of the year, Easterbrook entered the Giants rotation nearly full time in the second half of the season and had some amazing outings. On August 6, Easterbrook struck out 16 Wilmington Blue Rocks. His other claim to fame came two and a half weeks later, when he threw a no-hitter on August 21 against Harrisburg. Teammate Joe Micciche had thrown one earlier in the year, on July 11, against Harrisburg. (Courtesy Ruth Cunningham.)

Some players stick around after playing with the Giants, as was the case with a young Bill Drake (right). Drake, with teammates Harry Wilson (left) and Thomas Korczowski (center), played for the Giants for one season as a shortstop and later became the head softball coach at Mercer County Community College. He is a Hall of Fame softball coach and a Hall of Fame guy. Korczowski joined Mays and pitcher Joe Micciche on the post-season all-star team and set a record with 40 doubles in 1950. (Courtesy Ruth Cunningham.)

Few possessed skills behind the plate like Len Matte. Matte remained in Trenton as a successful insurance broker after his playing days with the Giants and is credited, along with Mo Cunningham, with helping Willie Mays get adjusted to Trenton. There is no doubt that Mays refined his famous basket catch in the Negro Leagues and in the minor leagues, but some credit Matte for helping Mays with the basket catch. (Courtesy Ruth Cunningham.)

Scorecards at minor-league baseball games at Dunn Field were an important advertising tool. Not only that, but the local businesses were an avenue for the Giants' players to make extra money. In this advertisement, manager Tommy Heath is sporting a Northcool suit from Maury Robinson's men's store.

Dunn Field, the home of Trenton baseball during the 1930s and 1940s, was an all-purpose field for Trenton Catholic High School that was converted into a minor-league stadium. The lights came with the Senators when they arrived in 1936. Not only were there a number of baseball games played here, but during that time period, the field doubled as a high school football field as well. (Courtesy the Trenton Public Library.)

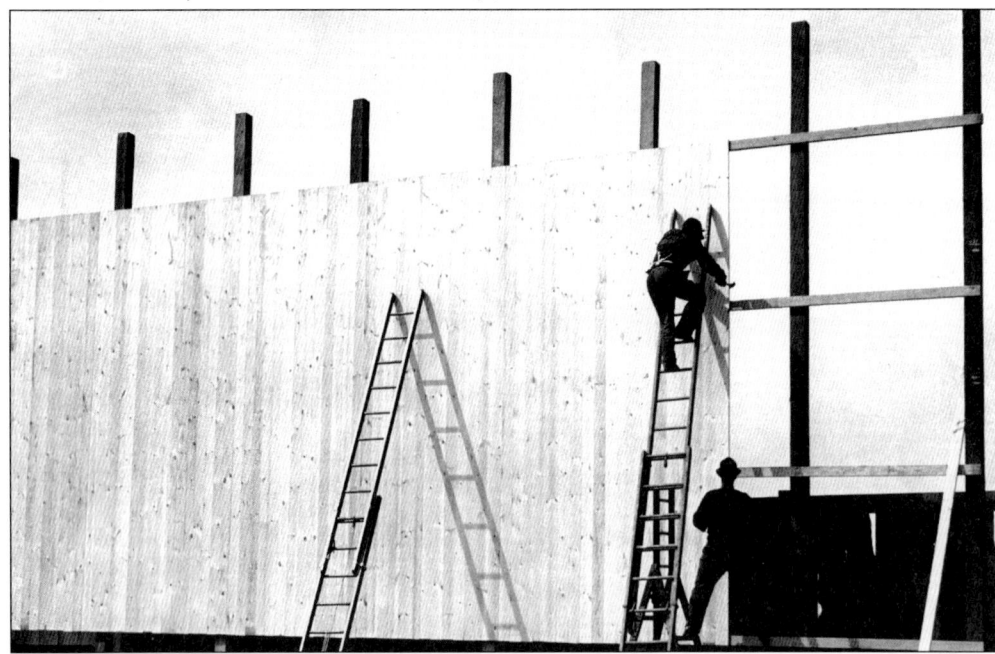

Workers are busy preparing the field for the baseball season by putting up the wood panels that would eventually house the many billboards that lined the outfield fence at Dunn Field. The facility was called a pitcher's ballpark because of its deep lines, but it was only 385 feet to center field. The lights were not great, but the ballpark did draw crowds for a number of years before the Giants left for good in 1950.

Two
BASEBALL RETURNS TO TRENTON

On the site of Waterfront Park, seen in this aerial shot, there used to be an abandoned factory that once housed a ketchup business. As you can see by this 1993 photograph, the banks of the Delaware look naked without the ballpark. The site of the ballpark is next to the small white building on the right. Most of the area is taken up by a make-shift parking lot that eventually became home plate. (Courtesy the *Times* of Trenton.)

During the 1993–1994 winter, poor weather continually delayed the construction of the stadium. This photograph and the photographs following in Chapters Two and Three were taken by Dave Schofield.

Progress during the winter of 1993 was rapid at first. Here, the steel structure is nearly complete and the outer shell of the 6,300-seat facility is evident to everyone who worked and drove along the Delaware River. Once the calendar flipped to 1994, though, the snow and ice fell often and with a purpose, meaning that construction was slowed in January and February.

One of the best aspects of playing in Trenton is the attention given to the team by the media. Here, Tom Runnells is being interviewed by New Jersey Network, a public television station run by the state of New Jersey.

On a cold December day in Princeton, Thunder manager Tom Runnells, the former skipper of the Montreal Expos, is introduced to a crowd of more than 30 members of the media. Runnells, who managed the team after its move from London, Ontario, will go down in Thunder history as the franchise's first manager. The team, which the previous season finished with 63 wins, ended the 1994 campaign with a 55-85 record, the worst in the Eastern League.

In this photograph, the owners of the Thunder are all smiles as the team introduces manager Tom Runnells to the members of the media. From left to right are Joe Caruso, Sam Plumeri, Jim Maloney, and Joe Finley. Two of the driving forces behind the team, Maloney and Finley, used to attend minor-league games in Reading and Wilmington but always dreamed of a chance to own a team themselves.

The introduction of manager Tom Runnells in 1994 also featured the unveiling of the Thunder uniforms. Thunder intern Geoff Brown shows off the road grays to Mercer County Park commissioner Frank Ragazzo (left), an unsung hero in the growth of the Thunder, and radio personality Ted Efaw (center with beard). Brown later became the assistant general manager of the Norwich Navigators and the general manager of the Single-A Lakewood Blue Claws.

This eventually became the concourse at Waterfront Park with concession stands, bathrooms, and the team's merchandise store. The seven little pipes that are sticking up through the floor of the concourse eventually became a part of the stadium's press box.

When the idea of putting a state-of-the-art ballpark in Mercer County first came up, many people thought Mercer County Park in West Windsor would be the ideal site; but politicians such as Mercer County executive Robert Prunetti and Mayor Doug Palmer of Trenton, along with the ownership group of the Thunder, wanted the stadium to sit along the Delaware River. As the field continues to be laid, the view of the Delaware River and the state of Pennsylvania is crystal clear from atop the stadium restaurant.

Sod continues to be laid in right field, but the seats and bleachers are all in place. Along the outfield wall is the skeleton of the team's majestic scoreboard, considered, at the time, the best in minor-league baseball. Also evident in this April 1994 photograph is the opening along the outfield on the right side. Eventually, once all of the construction equipment exited, the right field wall and bullpen were put in place. In the background, above the trees on the right side of the photograph, is the top of the old Champale factory, a landmark in Trenton that can be seen from the seats at Waterfront Park.

The finished product! Here, the sod is laid, but the outfield wall, billboards, and scoreboard are still under construction. Waterfront Park began with three levels of billboards in left field, left-center field, and right-center field and one level in right field. The single level of billboards in right field enabled fans to have a clear view of the Delaware River. The billboards were done by Maxwell Signs of Trenton, a mainstay in the city for nearly 100 years. Also, in the top of the photograph, little signposts ask fans and workers to stay off the sod while it settles into the ground. Work on the stadium was around-the-clock during the final weeks leading up to the season opener.

Just days before the scheduled April 27 opener, the final touches on the playing field are done, but the net behind home plate must be installed. In the left-hand corner are the unfinished luxury suites that opened during the middle of the 1994 season. The April 27 game against Albany-Colonie, the Double-A affiliate of the New York Yankees, never took place because Bill Evers, the Yankees manager, felt the playing field was unsafe.

While the stadium was being constructed during the winter of 1993–1994, the Thunder needed to find a home to run their operation. So, they settled on an abandoned bank next to the ballpark. On the first day of tickets sales, the bank's counters were a perfect setting to sell tickets. Instead of computers, which eventually made life easy in the new ballpark, some of the selling was done out of New Era Hat boxes.

The unexpected road trip lasted so long, that the first-ever Thunder team photograph had to be taken at Veterans Stadium, instead of Waterfront Park. Included in the photograph is Phil Stidham (back row, fourth from the right), the first Thunder player to reach the major leagues. He was promoted to the Triple-A level so quickly that he never played a game at Waterfront Park.

Because the construction on Waterfront Park was delayed, the Thunder played their first 26 games of the 1994 season on the road. There were regularly scheduled road games, but the Thunder played home games in Wilmington, Delaware, Reading, Pennsylvania, and at Veterans Stadium in Philadelphia. In this photograph, switch-hitting Tony Clark connects on a home run against the Canton-Akron Indians at Veterans Stadium, the home of the Philadelphia Phillies. Thunder players look on from the third-base dugout. Although the season was a struggle, Clark earned Eastern League post-season honors by being named to the all-star team as its designated hitter.

Because the stadium was not finished on time, Thunder opening-day starter Brian Edmondson got a chance, along with his teammates, to play at Veterans Stadium in Philadelphia against the Canton-Akron Indians. Edmondson won the game 9-3. The team was 3-1 at Veterans Stadium.

It was old hat in Harrisburg when the Thunder opened their inaugural season on the road. A capacity crowd at Riverside Stadium saw the Harrisburg Senators win the opener against the Thunder 4-1, as the Thunder committed three errors and managed just three base hits.

The 1994 season featured the fresh faces of assistant general manager Brian Mahoney (left) and director of marketing Eric Lipsman (center). Not only that, but it brought the smiles of many dignitaries, including Sen. Bill Bradley, Democrat, of New Jersey. Senator Bradley, a former NBA star and graduate of Princeton University, was on hand on Opening Night in 1994 to throw out the first pitch. He later became the only presidential candidate (2000) to throw from the Waterfront Park mound.

Actor James Earl Jones made an appearance at Waterfront Park during the 1994 season on behalf of Bell Atlantic Yellow Pages. Jones is seen here at the park reciting the national anthem to the crowd at a sold-out Thunder game.

Boomer, the Thunder mascot, is a thunderbird that stands over six-feet tall. The front office was searching for a mascot that would help in the community but also entertain the crowd during Thunder games. Boomer is blue, with a bright yellow beak. Boomer normally wears oversized, futuristic sunglasses as well. He was designed by Bill Pae, whose son Todd was an original member of the Thunder front office. Bill Pae is a United States postal worker, as well as a nationally recognized artist.

The batboy is an important part of the any baseball game. Here, a traditional baseball prank has been played on batboy Charles "Chuckie" Belmont. Unbeknownst to Belmont, someone placed a cup on top of his helmet with chewing gum. For nearly two innings, Chuckie, who was the Thunder's batboy for four seasons and later went on to study at the University of Pennsylvania, roamed the field for bats with a cup on his head.

Catcher Joe Perona (left) and right-handed starter Ken Carlyle gaze out from the Thunder dugout. Carlyle was one of the steadiest starting pitchers the Thunder had in 1994. A native of North Carolina, Carlyle and lefty Mike Guilfoyle pitched well enough to earn mid-season all-star honors for the Thunder. Perona, meanwhile, was loved by the fans at Waterfront Park. At the end of the 1994 season, he was voted the "fan favorite" and received a watch from Hamilton Jewelers for his efforts. It is a tradition that is still going strong after 10 years.

Brian Edmondson (left) and Trever Miller were two of the Detroit Tigers brightest prospects in 1994. Edmondson, from California, started the first game in Thunder history at Harrisburg's Riverside Stadium. Miller, a lefty who is still pitching in professional baseball, threw the first pitch at Waterfront Park.

Thunder photographer Dave Schofield made sure to capitalize on the opportunity to make the Thunder players look like throwbacks, with vintage gloves and a vintage bat. Second baseman Kelly O'Neal (left), catcher Joe Perona (center), and pitcher Ken Carlyle play Trenton Giants. The uniforms, done especially for Turn Back the Clock Night by Ebbetts Field Flannels, were gray with black letters and numbers trimmed in orange; the exact uniforms once worn by the Trenton Giants and Willie Mays.

Thunder hitting coach Kevin Bradshaw makes some adjustments to the team's lineup. Bradshaw, who lasted less than two months before he was named manager of Detroit's Gulf Coast League team, is wearing a replica Trenton Giants uniform on Turn Back the Clock Night at Waterfront Park. Bradshaw later returned to a finished Waterfront Park during the 2002 season as the manager of the Erie SeaWolves, the Double-A affiliate of the Detroit Tigers.

Thunder center fielder Justin Mashore, a confident kid who hailed from California, walks back to the dugout following a strikeout. Mashore was a solid center fielder for the Thunder in 1994 but scuffled as a hitter. Mashore was presented with the No. 24 when he arrived in Trenton. It was the same number worn for so many years in the big leagues by center fielder Willie Mays. Mashore returned to the Thunder several years later as a member of the Boston Red Sox organization.

One of the many duties of a starting pitcher is charting a game prior to the start. Here, Thunder left-hander Trevor Miller sits alone in the Thunder dugout charting that night's starting pitcher. The dugout, which later evolved like the stadium, is in its infant stages, with just a wooden bench and no bat rack. Despite a franchise record 16 losses in 1994, which included 9 straight at one point, Miller progressed through the minor leagues and made it to the big leagues with the Houston Astros.

Honoring the past glory of Trenton on the team's first-ever Hall of Fame Night is the author (left), Thunder manager Tom Runnells (right), and the son of the late George Case, George Case III. Case accepted the honor on behalf of his deceased father. George Case II played for the Trenton Senators.

Also inducted on that same night was Harold "Bus" Saidt, the radio announcer for the Trenton Giants and Hall of Fame sportswriter for the *Times* of Trenton. In the photograph is the author, Helen Saidt (holding the plaque), Tom Runnells, and Jim Gauger, the sports editor for the *Times* of Trenton.

Thunder manager Tom Runnells takes time out during batting practice to talk to veteran third baseman Dean DeCillis. When DeCillis's playing career came to a close, he became a scout and is currently the East Coast cross-checker for the Philadelphia Phillies organization.

Thunder shortstop Kirk Mendenhall is in the ready position as the Thunder take on the Binghamton Mets. Mendenhall is shadowed by the many outfield billboards that are part of the setting at every minor-league baseball facility. Mendenhall committed a team-high 35 errors in 1994, a record that still remains in tact.

Brandon Hardison, the first public address announcer at Waterfront Park, is seen here auditioning for the position that he held until the conclusion of the 1997 season. Hardison was a graduate of Trenton Central High School and was blessed with some amazing pipes.

Part of the draw of minor-league baseball is the in-between inning events that take place to entertain the fans. Here, a young Thunder fan is about to race the Thunder mascot, Boomer, around the bases for a chance to win a 10-pound Nestlé Crunch bar. Mike Hardge of the Harrisburg Senators gives the youngster some moral support before his journey around the bases begins.

Every new franchise needs a superstar and the Thunder had that in 1994 with first baseman Tony Clark. Seen here in Reading, Pennsylvania, Clark, a six-foot-seven-inch-tall former basketball player from El Cajon, California, hit 19 home runs in his first full season of professional baseball and became the first Thunder hitter to launch a home run into the Delaware River, which is located beyond the right field wall at Waterfront Park. A mainstay in the Thunder lineup, Clark was also a mainstay in the Trenton community. Here, Clark, whose No. 33 jersey was the first number retired by the Thunder, signs some autographs prior to a game.

Opening night at Waterfront Park included many political dignitaries, including Gov. Christine Todd Whitman, who was elected the previous November. Governor Whitman shows that she not only could lead the state, but she had a pretty good fastball as well.

Thunder manager Tom Runnells is all smiles as he poses with singer and songwriter Terry Cashman. Cashman, who penned and performed the song "Willie, Mickey and the Duke," was on hand on opening day in 1994 to sing the national anthem.

The waiting finally produced the inaugural game at Mercer County Waterfront Park against the Binghamton Mets, the Double-A affiliate of the New York Mets. Here, starting pitcher Trever Miller delivers the first-ever pitch at Waterfront Park to Binghamton center fielder Ricky Otero. Game 1 was played on May 9, 1994, and was won by the Thunder 5-2. Eventual fan favorite Joe Perona is the catcher.

Blessed with an amazing amount of untapped talent, Brian DuBose has the distinction of launching the first home run in Thunder history. It came against the Harrisburg Senators in the opening home game of the 1994 season. "Doobie" finished the 1994 season with a .225 batting average, nine home runs, and 41 RBIs. He also stole 12 bases.

There were not a lot of dominant performances by the Thunder during the 1994 season, but Shannon Withem's 14 strikeouts against the New Haven Ravens on August 14 was one of those few performances. Withem, shown here accepting the Pitcher of the Month Award from the United States Postal Service, finished the season with a 7-12 record and five complete games. His 14-strikeout performance is still a Thunder record.

The unfinished dugouts of Waterfront Park in 1994 housed not only the players but also the members of the media who were enjoying the afternoon. The Thunder had two newspapers that traveled with them during the 1994 season, which was unheard of in the Eastern League. Larry O'Rourke (left), who covered the Thunder for the *Trentonian*, was one of the main writers on the beat. Here, he and Thunder outfielder Brian Saltzgaber study something near home plate.

It took the Thunder a while to play their first home game, but on May 9, 1994, a capacity crowd watched Tom Runnells (tipping his hat) and his team finally take the field. Down the line, the starting lineup is shown that was enlisted to face the Binghamton Mets in that opener. Smack dab in the middle of that lineup and taller than the other players is Tony Clark.

Kelly O'Neal's statistics were nothing to write home about in 1994, but the infielder has the distinction of being the first batter in Trenton Thunder history when he faced Harrisburg's Rod Henderson in this shot. O'Neal played in only 20 games for the Thunder in 1994 and hit .207.

Because the stadium was delayed, the Thunder players were housed in the visitor's clubhouse for the first year. The players enjoy a little down time prior to a game. From left to right are Kelly O'Neal, Tony Clark, Brian DuBose, and Darren Milne.

During the first year of Thunder baseball, there were two players with roots in New Jersey who had a chance to play close to home. One was utility man Joe DelliCarri, a former standout at the University of Pennsylvania and a resident of Bergen County. DelliCarri was one of the leaders of the 1994 Thunder and is now a scout for the New York Mets organization.

In honor of the Trenton Giants, the Thunder turned back the clock in 1994 and wore replica uniforms and hats from the early days of Trenton baseball. This re-creation is compliments of photographer Dave Schofield and pitchers Pat Ahearne (left) and Rick Greene (sliding). Greene went all-out with a handlebar mustache and all.

The sudden death of Thunder owner Jim Maloney (left) just days after the 1994 season sent shock waves through the community. Maloney, a lawyer by trade, was a die-hard Brooklyn Dodgers fan whose first love was baseball. He arrived at the Thunder front office each day with a yellow legal pad full of ideas. When he passed away in September 1994 as a result of a heart attack, his wake drew hundreds of people, including former governor Jim Florio and many politicians from South Jersey. He led a full life but never saw the pinnacle of the Thunder success. He was the person who laid the groundwork for success. In the photograph below, taken at the end of the season as the Thunder celebrated their first year, Maloney (center) spends time chatting with fellow owner Sam Plumeri and his wife Josephine.

Three
TRENTON CHANGES ITS SOCKS TO RED

The Tigers lasted just one season in Trenton and then headed south to Jacksonville, Florida. From there, it was time for a new direction and that direction included the fabled Boston Red Sox, who played previously in New Britain. The press conference to announce the affiliation with the Red Sox was held in front of a capacity crowd in the Thunder restaurant. Here, Red Sox general manager Dan Duquette discusses the two-year contract with the media. To the right is Thunder general manager Wayne Hodes, and to the left, closest to the podium, are Thunder owners Joe Finley (closest to podium) and Dick Stanley.

One of the many changes from the 1994 season was the Thunder uniforms. Although the style, kelly green pinstripes at home with a kelly green hat, stayed the same, the lettering changed. Thunder owner Sam Plumeri felt spry as he showed off the new duds, which included an easier-to-read font. It is a style that was still evident in 2003, although the dominant color has gone from kelly green to royal blue.

The affiliation with the Red Sox produced some highly touted prospects, as well as new uniforms. The tough-to-read letters were clearer in 1995, while the numbers looked like actual numbers. Winding up is one of the top prospects in the Red Sox organization, Jeff Suppan, who started 15 games for the Thunder in 1995 and went 6-2 with a 2.36 ERA before his July 16 promotion to the Red Sox. The oddity in the promotion was not that Suppan went right to the big leagues but that Thunder pitching coach Al Nipper was promoted with him. Suppan was often compared to future Hall of Famer Greg Maddux because of his control and follow through. He still holds the record for lowest ERA in a season for the Thunder with his 2.36 mark in 1995.

The Phillie Phanatic has made many appearances at Mercer County Waterfront Park. Prior to entertaining a sold-out stadium in June 1995, the Phanatic entertains Thunder left-handers Rafael Orellano (left) and Shawn Senior (right).

Outfielder Greg Blosser came to the Thunder in June 1995 to find his stroke. The former major leaguer was hitting just .200 with one home run for Pawtucket at the time. He joined the Thunder in New Haven and finished the season with 11 home runs. He holds the record for consecutive games with a home run when he connected on five in a row from July 25 to July 30. Not only that, but he also hit two home runs in the same inning on September 3, 1995, against Canton-Akron.

Third baseman Bill Selby arrived in Trenton in 1995 after hitting 20 home runs the previous season in 1994 and provided a little pop in the middle of the Thunder lineup. The left-handed hitting Selby, seen here in a vintage Trenton Senators uniform, hit 13 home runs and collected 68 RBIs in 117 games. He played 74 games at third base and 35 at second. He made his major-league debut two years later with the Red Sox and then moved on to the Cleveland Indians.

Although his overall numbers were not staggering, Dean Peterson had the distinction of throwing the first one-hitter in Thunder history on April 24, 1995, against the Bowie BaySox. The right-hander from Cortland, Ohio, won four games in 1995 in 20 games for Ken Macha's squad.

63

Lou Merloni, who could play any position in the infield, settled in as one of the fan favorites the minute he arrived in 1995. He is probably the most popular Thunder player of all time. Merloni played for the Thunder from 1995 to 1997 and returned with the Red Sox for the exhibition game in 1998. He hit just .232 bouncing up and down the Red Sox system in 1996 but batted .277 with one home run and 30 RBIs in 1995, when the Thunder won their first divisional title.

The first general manager for the Thunder was New Jersey native Wayne Hodes, who made his initial mark in minor-league baseball with the Rancho Cucamonga Quakes in the California League. He was hired in December 1993 to run the Thunder and built the franchise from the ground level for six seasons. He was Minor League Baseball's Executive of the Year in 1996 and the Eastern League's Executive of the Year in 1995 and 1998. When he left to take a position with the New Orleans Saints, the Thunder had drawn more than two million fans and were named the Minor League Baseball Organization of the Year in 1998.

In 1995, new manager Ken Macha went through spurts during the season when he did not have a hitting coach or a pitching coach, which meant that he had to do a little more. Macha won 73 games in 1995 and 86 games in 1996, but fell short in the playoffs both years. Macha was inducted into the Thunder Baseball Hall of Fame, along with David Eckstein, in November 2003.

Waterfront Park attracted the attention of several football coaches, including former Eagles coach Dick Vermeil, who is on hand to throw out the first pitch, but takes time to talk to Thunder manager Ken Macha as well as shortstop Nomar Garciaparra. Vermeil, looking rested and fit, later got back into coaching with the St. Louis Rams and led them to a Super Bowl title in 2000.

Each minor-league city has the added bonus of watching the evolution of an organization's prospect. Back in 1950, the fans in Trenton saw Willie Mays. This group of fans not only saw Tony Clark in 1994 but also Nomar Garciaparra in 1995. The slender shortstop, whose name comes from his father's name spelled backwards, arrived in Trenton after one season in Single-A baseball and hit .267 with eight home runs and 47 RBIs. Although he had a solid season, no one anticipated the explosion that led to his rise to all-star status with the big club.

Two of the rising baseball stars in 1995 were Nomar Garciaparra (left) and Mets outfielder Jay Payton (right). The two were both drafted out of Georgia Tech and both played in the Double-A Association All-Star Game in Shreveport, Louisiana, in 1995. Payton is currently an outfielder for the Colorado Rockies.

Al Downing (left) looks as good now as he did when he pitched in the big leagues for the Dodgers and Yankees. Downing returned to his native Trenton in 1995 and was inducted into the Trenton Thunder Baseball Hall of Fame. During the festivities, Downing had a chance to pose with the marketing director, Eric Lipsman, in the press box. A standout pitcher in the Babe Ruth Leagues in Trenton, Downing went on to play 17 years in the big leagues. He later became a broadcaster for the Dodgers and CBS radio.

The plaque that was presented to Al Downing was given by Thunder hitting coach Rico Petrocelli. Their major-league playing careers mirrored each other. Downing was inducted along with Thunder owner Jim Maloney, who passed away the previous September.

Left-hander Shawn Senior, who grew up in nearby Cherry Hill, won 11 games for the Thunder in 1995, giving the Thunder a solid one-two punch along with teammate Rafael Orellano. Senior came back in 1996 to win five more games before retiring from baseball to go back to college and earn his degree.

Former Red Sox star Rico Petrocelli, who hit .251 with 210 home runs in 13 years in the big leagues, joined Ken Macha's staff on June 2, 1995, as the team's hitting coach, two months after the start of the season. Petrocelli was a longtime coach with the Red Sox and is one of the most recognizable men in Red Sox history.

Trot Nixon joined the Thunder in 1995 as a heralded No. 1 pick. This photograph is a foreshadowing of two big-league teammates: Nomar Garciaparra (left) and Trot Nixon (right). It took Trot an extra year to reach Triple-A status, but nobody worked harder to try and refine his skills and his youthful temper. The former all-state quarterback, who was heading to North Carolina State before signing with the Red Sox, would run through a wall to make play. In fact, in 1995, he nearly ran through the right field wall chasing a line drive.

Thunder photographer Dave Schofield took this aerial shot of Waterfront Park during the 1995 season, showing a packed house for one of its businessperson's specials. You can see the Delaware River running alongside the stadium, separating New Jersey and Pennsylvania, as well as two of the three automobile bridges that take you from one state to another. The third bridge is the New Jersey Transit and Amtrak Bridge. Nestled at the top of this photograph is the capital building in downtown Trenton.

Former Thunder assistant general manager Brian Mahoney is seen in the Thunder Dugout Gift Shop with one of his favorite people, owner Sam Plumeri. Mahoney left the Thunder at the conclusion of the 1996 season, after running the operations surrounding the Double-A All-Star Game, to take over as general manager of the Norwich Navigators, the Double-A affiliate of the New York Yankees. Mahoney is now in the big leagues as a marketing representative with the Phillies.

During the 1995–1996 season, the Thunder wore the replica uniforms from the Trenton Senators, baggy pants and all. Here, reliever Mike Blais (No. 41), Todd Carey (No. 18), and former major leaguer Greg Blosser (No. 19) wait to head out to their positions while the national anthem is performed.

On Turn Back the Clock Night in 1995, Nomar Garciaparra (left), Sam Plumeri, Ryan McGuire (with a bat), and Rico Petrocelli (right) soak up the moment. McGuire, a steady left-handed hitter from UCLA, finished second in the league in hitting in 1995 with a .333 batting average and third in on-base percentage with a .414 mark. He also had seven home runs and 59 RBIs.

In 1994, Clyde "Pork Chop" Pough played at Waterfront Park as part of the Indians organization. In 1995, he signed with the Red Sox and joined the Thunder, becoming an instant hit with the fans. His smile, personality, and name brought excitement to the game. In 97 games in 1995, he hit .278 with 21 home runs and 69 RBIs before being promoted to Triple-A Pawtucket. In his final game on July 20, he received a standing ovation from the crowd that lasted nearly three minutes. It was a moment so amazing that it was featured in *Sports Illustrated* that week.

They called themselves the "Grumpy Old Men," but they were far from that. Along the back row, from left to right, are Brent Knackert, Bryan Eversgerd, and Eric Schulstrom. Left-hander Ken Grundt is kneeling. Some veterans who are relegated to the ranks of Double-A after long years toiling in the minors do not take it so well. These four accepted their assignment to bring along a young bullpen with open arms and were a breath of fresh air for the fans and the clubhouse. For two months, they were collectively dominant for Ken Macha's club.

Some players embraced the minor-league experience better than others. Here, half of the Grumpy Old Men, Brent Knackert (left with long hair) and Eric Schulstrom (with the sunglasses), step outside the ballpark and help hand out coffee mugs to many of the surprised fans at Waterfront Park. It is safe to say that Knackert was the leader of the Grumpy Old Men.

One of the two left-handed members of the Grumpy Old Men was Ken Grundt, who appeared in 12 games with the Thunder before his promotion to Triple-A baseball. Grundt had one victory and pitched in 12.2 innings but did not allow a run. He and Bryan Eversgerd, who was later traded to the Cardinals, gave Ken Macha a potent duo from the left side in the early part of the 1996 season. It also helped them to a 17-6 record in April, which is still a franchise record.

Brent Knackert was the leader of the Grumpy Old Men, but he was also the leader of the Thunder bullpen during the first month and a half of the 1996 season. To say he was automatic was an understatement. In 11 games before his promotion, Knackert had 10 saves and an ERA of 1.38.

Following Knackert's promotion and eventual stint in the big leagues, right-hander Reggie Harris was slotted into the closer's role for the Thunder. Harris threw hard and overmatched the Double-A hitters, tying and surpassing Knackert's franchise record for saves in a season. He closed the door on 17 games and finished with a 2-1 record and 1.46 ERA. His save total stood until the 2001 season, when it was broken by Corey Spencer.

The Thunder were fortunate to see many No. 1 picks play at Waterfront Park. None were more emotionally charged than North Carolina native Trot Nixon. The No. 1 pick by the Red Sox in the 1993 draft, Nixon played two seasons in Trenton. His first season was 1995 when he hit .160 after his promotion from Single-A Sarasota, where he hit .303 in 73 games.

Adam Hyzdu arrived from the airport in the third inning of a game on April 27, 1996, and made his debut for the Thunder late in the game as pinch-hitter. In his first at-bat, he belted a home run that helped the Thunder to a come-from-behind win over New Britain. He finished the season tied with Tyrone Woods for the franchise record in home runs with 25 and a league and franchise best batting average of .337. The former No. 1 pick from the Giants eventually made it to the major leagues with the Pirates.

At the age of 20, Carl Pavano came to Trenton with 10 minor-league wins and added 16 victories in 1996. He helped the Thunder to first place in the Southern Division of the Eastern League, and his 9-5 record in the first half of the season earned him a spot on the Double-A Association All-Star team as the starting pitcher. Pavano won nine games during the first half of the year in 1996.

At his request, Tyrone Woods used to walk up to the plate with the theme from the hit show *Sanford and Son* playing over the loud speaker. His ability was no laughing matter in 1996. Wearing No. 55, Woods, a veteran of the Eastern League, having played with the Harrisburg Senators, dominated Eastern League pitching with a franchise record 25 home runs (he tied Adam Hyzdu that season). He was part of a team that led the league with 150 home runs that season.

What these three players accomplished collectively in 1996 will be hard to ever duplicate. Posing in the old-time Trenton Senators uniforms, Tyrone Woods (left), Todd Carey (center), and Adam Hyzdu (right) show off their home-run bats. The three combined to hit 66 of the team's 150 home runs in 1995. Woods and Hyzdu had 25 each, while Carey had 16. They also combined for 229 RBIs.

The Red Sox went out of their way to accommodate Thunder owner Sam Plumeri, even letting him ride around spring training in Carl Yastrzemski's golf cart. The speedy Plumeri takes a moment to pose with his wife Josephine and Ken Macha, the manager of the Thunder in 1995 and 1996.

The heritage of Trenton is embraced throughout the tenure of the Thunder. In this photograph, team photographer Dave Schofield reaches back into the archives to stage this vintage shot with the Thunder players wearing replica uniforms from the Trenton Senators. Knuckleballer Jared Fernandez leads the way, followed by left Rick Betti, Australian right-hander Brett Cederblad, and reliever Mike Blais.

The 1996 season was a special one for the Thunder and their fans. Not only did the team win 86 games, but they had a stretch in April where they won 13 straight, which is still the club record. Here, a Thunder fan walks through the crowd with a broom, as well as the dates of the three sweeps the Thunder had during the winning streak.

Arguably the most dominant pitcher in Thunder history for one full season, right-hander Carl Pavano was named Baseball America's Pitcher of the Year in 1996. Pavano, a native of Southington, Connecticut, and a Red Sox fan growing up, led the Thunder to the postseason and won eight straight games from July 3 until the end of the season. His last regular season loss was on June 28 against the Canton-Akron Indians. He also went 5-0 with a 0.72 ERA in the month of August. Pavano's winning streak was stopped in Game 1 of the playoffs against Harrisburg.

Voted the fan favorite during the 1997 season, Randy Brown made some impressive noise on the offensive front in 1996, when he hit 11 home runs and collected 38 RBIs. The pinnacle for Brown's career with the Thunder came in April, when he not only hit a three-run home run to tie the game late, but in his next at-bat against the New Britain Rock Cats, he hit a grand slam to win the ballgame. Those seven RBIs are still tied for the franchise record.

The Thunder hosted the 1996 Double-A Association to record crowds. Some of the players who participated are seen here. They are, from left to right, Todd Carey, Ricky Stokes of the Knoxville Smokies, Bubba Trammell, Bubba Smith, and Mike Cameron. Trammell and Cameron are still on big-league rosters. Trammell is a member of the Yankees and Cameron is the starting center fielder for the Seattle Mariners.

The Double A Association All-Star Game brought the attention of the baseball world to Trenton New Jersey. The top Players from the Eastern, Southern and Texas Leagues were showcased to a national TV audience on ESPN 2. 8,369 fans saw the game in person as the National league defeated the American League 6-2. The Thunder's own Carl Pavano started the game and pitched two innings. Todd Carey had a triple, with an RBI and run scored, while Walt McKeel had a single as well.

American League All-Stars

National League All-Stars

The Double-A Association All-Star Team brought the colorful uniforms from the Texas, Southern, and Eastern Leagues together for one exciting night. The game, which was broadcast by the Armed Forces Radio and Television Service, featured future big-league stars Todd Helton (bottom photograph, first row, first player on the left), Paul Konerko (bottom photograph, first row, third player from the left), Vladimir Guerrero (bottom photograph, first row, first player on the right), and Mike Cameron (top photograph, third row, fourth from the left). It also featured the Thunder coaching staff, Ralph Treuel, Ken Macha, and Gomer Hodge (top photograph, first row, fifth, sixth, and seventh from the left, respectively), as well as Phillies broadcaster Larry Andersen (bottom photograph, first row, fifth from the left), who was the National League's pitching coach. The American League won the game 6-2 in front of 8,369 fans.

His unorthodox batting style always seemed to be concerning, but Walt McKeel got the job done at the plate and behind the dish as the Thunder catcher in 1995, 1996, and 1997. He was a member of the Double-A All-Star Game in 1996 and voted the fan favorite for the season. McKeel went on to hit .302 with 16 home runs and 78 RBIs that season. He led the team in hits with 140 and in runs with 86.

During their tenure with the Red Sox, the Thunder were blessed to have great leadership in the clubhouse. Ken Macha, who went on to manage the Oakland A's, proved it during his two years at Waterfront Park. The longtime coach in the big leagues with the Expos and Angels wanted to manage, so he gave up the major-league life for four years—two with the Thunder—to earn his stripes in the minors.

Brown University graduate Todd Carey had a sweet stroke from the left side of the plate but also was able to play a handful of positions in the infield. A member of the 1996 all-star team, Carey played two seasons for the Thunder. He still holds the record for extra base hits in a season with 57 in 1996. In this picture, he is turning two with future Thunder outfielder Israel Alcantara sliding in against him.

Tony Clark's impact on the Thunder goes beyond the 21 home runs he hit in 1994. The Thunder were looking for an identity and he helped provide it that first season. In 1996, the team honored Clark by inducting him into the Thunder Hall of Fame and, also, retiring his No. 33. In this photograph, with his Detroit Tigers team taking the night off, Clark addresses the Thunder crowd and watches his number as it is hung above the stadium restaurant behind home plate for everyone to see. Tony Clark's night was not complete without a moment with Thunder owner Sam Plumeri. The affable Plumeri, whose father Joseph had his hand in baseball back when the Giants and Senators played at Dunn Field, was at every game up until his death in 1998. The six-foot-six-inch-tall Clark has always been in touch with his Trenton roots.

83

He used to stride the plate with the theme from *Rocky* blaring through the sound system. David Gibralter played for the Thunder for three seasons and, over time, became a fan favorite. He was in the opening-day lineup for three straight years and collected 86 RBIs in 1997 and 97 RBIs in 1999. Both were top five of all time for a single season. He also holds the record for the most grand slams in franchise history with five.

The Thunder brain trust in 1997 included former big leaguers Dave Gallagher (back) as the hitting coach and Al Nipper (middle) as the pitching coach. Nipper was with the Thunder in 1995 before landing a job as the Red Sox pitching coach. He returned in 1997 to help out DeMarlo Hale (front). Gallagher later became the head coach at Notre Dame High School in Lawrence and then became the head coach at Mercer County Community College in West Windsor.

One of the great attractions of being affiliated with a major-league team is the opportunity to have one of the parent club's players come down to rehabilitate. During the course of the first 10 years, the Thunder had several superstars, including two-time Cy Young Award winner Bret Saberhagen, who first rehabilitated in Trenton in August 1997. During his time with the Red Sox, Saberhagen made a handful of visits to Trenton to rehabilitate his injured arm.

When Aaron Fuller arrived in 1995, he struggled to find his place on the offensive end for the Thunder. He returned to Single-A baseball in 1996 because of a surplus of free agent signings by the Red Sox but came back to Trenton in 1997 and set the standard for stolen bases with 40 and walks with 95. Fuller also collected 87 runs and six triples, both in the top five of all time in Thunder annals.

85

Ron Mahay is a former outfielder for the Red Sox who made his major-league debut against the Seattle Mariners in 1995 and had two hits. His time in the big leagues as an outfielder was short-lived because during the off-season, while playing for Red Sox coach Buddy Bailey, Mahay was fooling around on the mound. Bailey noticed a live fastball and great form and convinced the Red Sox that Mahay's worth would be more as a left-handed pitcher. So, Mahay returned to the Thunder as a hurler in 1997. After some success in the minors, he was summoned to Boston and became the first big leaguer since Skip Lockwood to play the field for one big-league season and return later as a pitcher.

There were not too many Red Sox prospects who had a sweeter swing from the left side of the plate than Andy Abad. After struggling at the plate and off the field in 1995—Abad and teammate Mike Hardge were allegedly involved in an altercation at a Trenton bar—Abad returned to Trenton in 1996 and remained at the Double-A level in 1997. When all was said and done, he was a consistent hitter who was one of the most accommodating in the community. He made his major-league debut with the A's in 2001 and had one at-bat.

Thunder second baseman Jim Chamblee was a big part of the team's success in 1998. The native of Texas made his way through the Thunder system as a third baseman before settling in at second. Chamblee hit .241 with 17 home runs and 65 RBIs with the Thunder. In the opening-day lineup, Chamblee hit second behind outfielder and good friend John Barnes and finished the season with 53 extra base hits, the second most in franchise history.

This photograph is of Thunder relief pitcher Sal Urso, who pitched at Waterfront Park in 1997 as a member of the New York Yankees organization and came to the Red Sox in 1998 and was assigned Double-A status. The left-handed Urso not only won the fan favorite award at the conclusion of the 1998 season, but he also showed off an amazing pick-off move that nearly eclipsed Rich Kelly's record for pick-offs in a season.

Left-handed starting pitcher Robert Ramsay was one of the anchors of the Thunder staff in 1998. Drafted out of the state of Washington by the Red Sox, Ramsay went on to win 12 games for the Thunder in 1998, the third most for a season, but set the high-water mark for strikeouts in a season with 166. That mark continued through the 2003 season. Ramsay was later traded to the Mariners, where he made his major-league debut.

When the Red Sox returned in 1998 for an exhibition game against the Thunder, Sam Plumeri got a chance to say hello to some of the team's former stars, including shortstop Nomar Garciaparra.

The exhibition game not only marked the first time since 1944 that a major-league team had played in Trenton, but it also gave the Thunder a chance to retire Nomar Garciaparra's No. 5 and induct him into the team's Hall of Fame. The Thunder presented Garciaparra with his jersey and invited his family, including his mother and father, to Trenton for the occasion.

The site of the Red Sox in Trenton was overwhelming for baseball fans in the city. The Thunder alumni, from left to right, are Nomar Garciaparra, Lou Merloni, Bret Saberhagen, Brian Rose, and Ron Mahay. They were asked to throw out the ceremonial first pitch. Also with the Red Sox but not seen in this photograph was former Thunder catcher Dana Levangie, who was the Red Sox bullpen catcher.

During most exhibition games, the major-league starters play an inning or two and then are taken out of the ballgame. To Garciaparra's credit, he stayed and played the entire game. The Red Sox trailed for most of the game but pulled it out in the end and won it 4-3 in front of 8,602 fans. The crowd remained the largest in club history until 2003, when Derek Jeter came to Trenton for rehabilitation.

Right-handed starter Brian Rose pitched for the Thunder in 1996 and teamed with Carl Pavano to provide a solid punch from two young prospects. Rose won 12 games for the Thunder in 1995 with a 4.01 ERA. He also had four complete games and two shutouts.

Thunder catcher Chad Epperson enjoyed his exhibition game experience. Not only did he connect on an early home run to give the Thunder the initial lead in this at-bat, but he also won the home-run contest prior to the game. Epperson played in Trenton for three seasons from 1997 to 1999. His best year was 1998, when he hit 15 home runs and represented the Thunder, along with Paxton Crawford, in the Double-A Association All-Star Game.

Sitting high atop the stadium restaurant at Waterfront Park are the three numbers the team has retired during its 10 years of existence. The first is former first baseman Tony Clark (33), the second is Jackie Robinson (42), and the third is Nomar Garciaparra (5). The disks still remain at Waterfront Park even with the affiliation change from the Red Sox to the Yankees.

Prior to the exhibition game, the Thunder and the Red Sox hosted a home-run contest to raise money for charity. Representing the Red Sox, from left to right, are Midre Cummings, Jim Leyritz, and Thunder favorite Lou Merloni. Representing the Thunder, from right to left, are Dernell Stenson, Joe DePastino, and Chad Epperson. Epperson won the contest and then hit a home run in the game as well.

When the Red Sox placed outfielder Dernell Stenson in Trenton in 1998, he was young and raw, but with amazing power potential. He made the jump from Sarasota and led the team in games played (138), at-bats (505), and home runs (24). Stenson is credited with one of the longest home runs ever, which went over the scoreboard (seen here over his right shoulder) in right-center field.

From the left side of the mound, Brian Barkley (left) had tremendous off-speed talent. From the right side, Jim Farrell had a curve ball that would drop off the end of a table. Barkley pitched for the Thunder for four seasons (1996 to 2000), while Farrell was with the Thunder for parts of three years. In 1997, the two won 12 games apiece for the Thunder. Barkley went on to win 30 games in his four seasons with Trenton, which is the most in franchise history. He also made his major-league debut in 2000 at Yankee Stadium.

The arrival of the Red Sox for their one and only exhibition game in Trenton was not only exciting for the fans and players but also for Thunder manager DeMarlo Hale (left). The all-time winningest manager in Thunder history gets a chance to chat with his boss, then–Red Sox manager Jimmy Williams.

Wilton Veras, a 21-year-old third baseman, had a sweet, yet unorthodox, swing and arrived in Trenton in 1998 with a world of promise. Veras hit .291 for the Thunder in 1998 and returned to help the team to 92 wins in 1999. He was later promoted to Pawtucket and found himself as the starting third baseman for the Red Sox during the 2000 season. Veras came back for a third tour of duty with the Thunder in 2002 and made the Double-A Association All-Star Game. He hit .336 in 2002.

A 1998 shot of Waterfront Park from behind home plate shows Sam Plumeri Field at its best, with a packed crowd on a Sunday afternoon and sunshine drenching the playing field. It also shows a terrific view of the Delaware River beyond the right field wall. The Thunder have enjoyed many milestones in Trenton both on and off the field. This sellout crowd is a common occurrence, particularly during a stretch from 1995 to 1999, when the team played near or above capacity each season. The picture below, taken a year earlier, shows that it did not matter if it was a night game or a day game, the crowds still came.

David Eckstein was an undersized infielder from the University of Florida who took the Thunder and the Red Sox organization by storm. A tireless worker, Eckstein was the team's leadoff hitter in 1999 and proved to be one of the best catalysts in Thunder history. He went on to hit .313, was a member of the post-season all-star team, and made it to Triple-A status the following season before being placed on waivers by Dan Duquette and the Red Sox. No matter, Eckstein was claimed by the Angels, and in 2002, was the starting shortstop and leadoff batter for the world champions. Eckstein and current Astros shortstop Adam Everett formed a fine double-play combination in 1999. It was not until he went to the Angels that they moved Eckstein to shortstop. In the fall of 2003, Eckstein joined former manager Ken Macha in the Thunder Hall of Fame.

Steve Braun was born in Trenton and attended Hopewell Valley High School. He had a 15-year career with several different teams, including the Kansas City Royals and the St. Louis Cardinals. After a brief stint as the Cardinals hitting coach, he was hired by a roving instructor with the Red Sox, and after going from team to team for several years, came home and took over as the team's hitting coach in 1999. He was inducted into the Thunder Hall of Fame in 1997. When the Thunder switched their affiliation to the Yankees, Braun came with them.

Morgan Burkhart became one of the best stories in baseball in the 1999 season when he was signed by the Red Sox out of the Independent League at the age of 26. He went on to hit 23 home runs in Sarasota before being promoted to the Thunder during the season. After hitting 12 home runs for the Thunder, Burkhart went to Triple-A in 2000 and made his major-league debut that season.

There were a number of individuals who helped carry the Thunder to the franchise record 92 wins in 1999. The ace of the pitching staff was right-hander Jason Sekany. Sekany, much like Pavano in 1996, used an overpowering right-handed windup to win 14 games and post a 3.35 ERA. Sekany won his final six decisions and also won the first playoff game against the Norwich Navigators. His luck and the luck of the Thunder ran out in the best of five series, though. Sekany lost the final game 3-2, despite pitching well.

New Jersey native and former big leaguer Mike Griffin took over as the Thunder pitching coach in 1999 and remained with the team until the Red Sox left for Portland, Maine, at the conclusion of the 2002 season. A steady and knowledgeable pitching coach, Griffin is credited with grooming several future major leaguers, including Tomo Ohka, Sun Woo Kim, and Casey Fossum.

When Sam Plumeri passed away at the end of the 1998 season, it left a big void in Trenton. A well-liked politician and family man, Sam was an instrumental voice in bringing baseball back to Trenton. His family, sons Joseph (also a Thunder owner), Sam, and Paul, and his wife Josephine, help unveil this beautiful bronze statue of Plumeri that sits outside Waterfront Park, as well as the sign designating the ballpark as Sam Plumeri Sr. Field at Mercer County Waterfront Park.

The 92 wins for the Thunder during the 1999 season made for a special year. At mid-season, manager DeMarlo Hale (center) and right-hander Sun Woo Kim (right) were selected to participate in the Futures Game at Fenway Park. The Futures Game shows the world the top prospects in each club. Joining Hale and Kim was former teammate Tomo Ohka, who had been promoted weeks earlier to the Pawtucket Red Sox, Boston's Triple-A affiliate. Kim won nine games in 1999 for the Thunder.

Before he was promoted to Triple-A in 1999, Tomo Ohka, a right-hander who was brought over from Japan by the Red Sox, went 8-0 for the Thunder in 12 games. He was unbeaten for the season, combining for a 15-0 record between Triple-A and Double-A.

The Futures Game also enabled Thunder manager DeMarlo Hale to meet up with former Thunder pitching coach Rich Bombard. "Bomby" was the pitching coach during the team's inaugural season in 1994 before he was hired by the Red Sox. At the time of this photograph, he was the pitching coach for Triple-A Pawtucket in the Red Sox organization. DeMarlo was named manager of the year in 1999, after his team won 92 games. He left the Thunder as the all-time winningest manager with 234 wins.

The Thunder were solid in all facets of their game in 1999. Up the middle, the defense was maintained by former first-round pick Adam Everett (No. 7) at shortstop, David Eckstein (No. 2) at second base, and the sure-handed Raul Gonzalez (No. 18) in center field. The three wait to go to their positions as the anthem plays at Waterfront Park. Everett was a solid shortstop for DeMarlo Hale, hitting double digits in homers and stolen bases in 1999.

Brad Tweedlie, who was originally the property of the Cincinnati Reds, arrived in Trenton in 1996 and spent the better part of four seasons with the Thunder. A hard-thrower, Tweedlie topped his fastball off in the high 90s. He is among the franchise leaders in games played by a pitcher.

Three pieces to the offensive juggernaut the Thunder had in 1999 were Raul Gonzalez (left), Virgil Chevalier (center), and Morgan Burkhart. Gonzalez set the record for RBIs in a season for a Thunder player with 103. Chevalier stuck around for a couple of seasons and later garnered the fan favorite award in 2001.

Virgil Chevalier was in Trenton for four seasons, from 1998 to 2001. Chevalier finished as the all-time leader in games played. His best year was 1999, when he hit .293 with 13 home runs and 76 RBIs, helping the Thunder to a 92-win season.

They did not come much better than Thunder infielder Nate Tebbs, who played for the Thunder from 1997 to 1999. He could play anywhere, and during his three seasons, he did. In 1998, Tebbs established the franchise record for hits in consecutive games with 21. His streak lasted nearly a month, from June 20 until it came to a close on July 16. Tebbs also holds the record for hits in a game, with six. He did that on April 12, 1999.

Center fielder Raul Gonzalez bounced around the minor leagues before he was signed as a free agent by the Red Sox and placed in Trenton. He had one of the best all-around seasons in Thunder history in 1999, batting .335, with 33 doubles, 169 base hits, 55 extra base hits, and 103 RBIs. The RBI total is still the highest in franchise history, while the batting average is second to Adam Hyzdu (.337).

Some players stand out because of the their ability, others because of their style. Andy Hazlett, a left-hander from the University of Portland, stood out for both reasons. An unorthodox windup hid the baseball from the opposition and allowed Hazlett to get a jump on the opponents. He won nine games in 1999 with the Thunder and came back to win six more in 2000 and post a 3.31 ERA, fifth best in Thunder history for a season. During that 2000 season, he was selected as the Thunder fan favorite.

The Thunder dugout could sense that the magical run of 1999 was coming to a close as they resort to rally hats in Game 5 of their series against the Norwich Navigators. The Navigators won the final game 3-2, ending a season that saw the Thunder win 92 games, the most in minor-league baseball, and earn the recognition of being Baseball America's Team of the Year. From left to right are Chad Epperson, Nate Tebbs, Adam Everett, and Virgil Chevalier.

When Shea Hillenbrand played for the Thunder in 1999 and 2000, it was obvious right away that he could hit. He is now a third baseman for the Arizona Diamondbacks. When he played for the Thunder, he began his career as a catcher, but in 1999, he tore up his knee and moved to first base the following season. It was in 2000 that the Red Sox started experimenting with him at third base. Hillenbrand holds the record for base hits in a season (171) and doubles (35). Hillenbrand, wearing a catcher's helmet, signs autographs for the young Thunder fans who have come out to see him play. Hillenbrand injured his knee during that 1999 season sliding toward the Thunder dugout for a foul ball. It was the last time he ever caught a game.

Former big leaguer Dave Gallagher, one of the most recognizable residents of Mercer County, was the Thunder hitting coach for two seasons before resigning in 1998. Gallagher was a graduate of local Steinert High School and Mercer County Community College. His history of working his way through the minor leagues for nine years before finally making it to the big leagues, along with his many years in the majors, made him the ideal minor-league hitting coach.

Jared Fernandez arrived in 1995 and spent parts of the next four seasons with the club. He had the distinction of being a knuckleballer, which was a treat for everyone who came to see him. In this baseball card, Fernandez's grip is clear. That grip and his longevity helped him become the third all-time winningest pitcher in Thunder history with 24 victories.

One of a long list of Thunder pitchers who made it to the big leagues, Paxton Crawford came to Trenton in 1998 with a major-league change-up that baffled Double-A hitters. Paxton had the distinction of being the starting pitcher for the Thunder in the team's exhibition game against the Boston Red Sox during the 1998 season. In all, Crawford won 13 for Trenton, spending two full seasons along the banks of the Delaware River.

Just prior to the 2000 season, Thunder general manager Wayne Hodes stepped down after six seasons to take a position with the New Orleans Saints. Rick Brenner, who only several months earlier was promoted to the position of assistant general manager, was named only the second general manager in Thunder history. Brenner and Boomer share a moment at the team's Welcome North Dinner.

Thunder radio announcer Andy Freed settles in for a pre-game radio chat with manager Billy Gardner. Gardner, the third Thunder manager, lasted two years and won 134 games during that time period. It was the first time the Thunder were under .500 for back-to-back seasons. Freed was with the Thunder from 1996 through 2000 before landing a job as the lead broadcaster for the Triple-A Pawtucket Red Sox.

Larry O'Rourke (left) covered the Thunder for the *Trentonian* with Brian Dohn, Jack Kerwin, and EJ Crawford, while John Nalbone (right) covers the Thunder for the *Times* of Trenton. Others, like Steve Cornell of the *Bucks County Courier Times* and David McDonough from Boston's *Diehard Magazine*, were also constants. Nalbone and Chris Edwards, who covered the team during its first three seasons before moving on to the Phillies, also traveled with the team. The legacy of the minor-league beat began with Herb Clark of the *Times* and John Dell of the *Trentonian*.

John Valentin had seen a couple of games at Waterfront Park as a spectator during the first six years the team was in Trenton. Little did he know that in 2001 he would get a chance to play for the Thunder while he was rehabilitating. The New Jersey native eventually made it back to the Red Sox after a short stint in Trenton.

Right-hander Josh Hancock shows off the lighter side of minor-league baseball as he sports a tie-die jersey while pitching for the Thunder in 2001. Hancock was with the Thunder for two seasons before being traded from Boston to Philadelphia in 2003. In two seasons with the Thunder, the popular Hancock won 11 games.

Right-hander Justin Duchscherer had one of the sweetest curveballs Waterfront Park ever set its eyes on. He pitched for parts of two seasons in Trenton, winning seven games in 2000 and six games in 2001. He went into the ninth inning on May 11, 2001, against New Haven in search of the first no-hitter in Thunder history, but a ground ball eluded third baseman Jorge DeLeon, and Duchscherer had to settle for a one-hitter. It was the second one-hitter in the Thunder annals.

R.J. Johnson played two seasons for the Thunder, 2000 and 2001, and made strides both years to become a big-league outfielder. He hit .269 with 30 stolen bases in 2000 and followed that up with a .282 average, 10 home runs, and 17 steals in 2001. He finished with 47 steals in his Thunder career. He also finished in the top five in three different seasonal categories and had a 17-game hitting streak along the way.

The Thunder continued their slide in the standings in 2001 and finished out of the playoff picture for the second straight season. Right-hander Marty McCleary harnessed his control to win nine games before the all-star break, tying Carl Pavano's club record. McCleary was selected to play in the 2001 all-star game in Round Rock, Texas, because of his efforts. He was promoted to Triple-A on July 12.

It is difficult to refine your skills as a closer in the minors because most organizations wait until a player is older before they make him a stopper. Cory Spencer was not as dominant as Reggie Harris, Pat Flury, or Brent Knackert in closing games, but his final numbers set him aside from the rest, as he established a franchise record for saves in a season in 2001 with 20. He did that with a 3-5 record and a 4.52 ERA in 55 games.

After a rather uneventful season in 2001, Tonanyne Brown returned to Trenton in 2002 and hit 12 home runs and collected 12 stolen bases. In 2002 alone, he collected 43 extra base hits, including nine triples, a franchise record.

The 2002 season marked the ninth year that the Thunder were in Trenton, and it is obvious the magic and attraction had not worn off. Although the team did not fair well in the standings, they did at the box office, drawing more than 404,000 fans for the year. It marked the eighth straight season the team had gone over the 400,000 mark in total attendance.

Kevin Youkalis joined the Thunder in July 2002 and came off the plane hitting. He finished with a .344 batting average in less than 200 at-bats and had five home runs during that time.

One of the more gifted athletes the Thunder has had in recent years, Freddy Sanchez was a Double-A Association All-Star in 2002 in the middle of the season and a big leaguer by the end of the year. In 80 games with the Thunder, Sanchez hit .328 with five home runs and 17 stolen bases. Although the Thunder finished second to last, he was one of the bright spots for the team.

Ron Johnson was the fourth Thunder manager, who took over the club in 2002 and led them to a fourth-place finish in the division. Johnson was a highly successful skipper in the Royals organization who was dealt a tough hand with the Thunder. Often times, his roster was short and his bullpen depleted, but Johnson's upbeat style kept the Thunder focused. He led the Thunder to a 63-76 record.

There have been few Trenton natives who have played professional baseball in the town of their birth. Jerry Salzano, a resident of nearby Hamilton and a graduate of Steinert High School, played two years with the Thunder, won the fan favorite award in 2002, and hit 18 home runs in two seasons with the Thunder.

Former college star Casey Fossum pitches here for the Thunder. Fossum lasted half of a season with the Thunder in 2001 before being summoned to Boston. There are only a few players who have made the jump from Double-A to the big leagues, but less have stayed for the long haul. Casey is currently pitching in the Red Sox rotation. He is currently fifth all-time in strikeouts in a season for the Thunder with 130 and was leading the league in strikeouts when he was promoted.

The Red Sox did an impressive job of finding talent over seas in Asia. Right-hander Seung Song, who possessed tremendous size, was one of the talented players to join the Red Sox from overseas. In 21 games in 2002, Song was 7-7 with a 4.39 ERA. He had 119 strikeouts in 108.1 innings. At that point, he was traded to the Montreal Expos and finished the season in Harrisburg.

CHASE THAT "GOLDEN THUNDER"

Minor-league teams around the country try to find that one gimmick that will set them aside from everyone else. Well, in 2002, with the help of fan-favorite Jake the Diamond Dog, the Thunder welcomed Chase to their growing family. Chase, a golden retriever, can be seen at every Thunder game retrieving bats and playing Frisbee in the outfield. Chase also visits area schools during the off-season.

Four
THE YANKEES ARE COMING

Thunder owner Joe Finley is seen here at the press conference announcing the Thunder's new affiliation agreement with the New York Yankees. Finley has been one of the driving forces behind the success of the Thunder and his second franchise, the Lakewood Blue Claws. Not only is Finley active with the Thunder, but he is also on the board of directors for Minor League Baseball. Also pictured is Mayor Doug Palmer of Trenton.

All of the sitting governors in New Jersey were visible at Waterfront Park over the years, including the most recent, Democrat James McGreevey. Governor McGreevey (right) joined Mercer County executive Bob Prunetti (center) and Mayor Doug Palmer of Trenton, and the rest of the Thunder faithful for the press conference announcing the new partnership between the Thunder and the Yankees.

A sign of the significance of the relationship between the Thunder and the Yankees was the number of media members who attended the press conference. Everyone watched as Brian Casham (left) and Joe Plumeri (right) signed the affiliation agreement on September 17, 2002. The affiliation was the third different one for Trenton in their 10 years, but it was certainly the most significant in city history.

Joe Plumeri is seen with New York Yankees Hall of Famer Yogi Berra at the press conference.

On the morning of the September 17 press conference, Thunder owner Joe Caruso (left) walks the right field line with Hall of Famer Yogi Berra (center) and Thunder director of marketing Eric Lipsman. Berra, who said he had dined in Trenton many times, was joined at the press conference by Doc Gooden.

When the Trenton Senators had Spencer Abbott as their manager, he was labeled a true managerial legend. Stump Merrill, the Thunder manager in 2003, can be termed the same kind of legend. His first year as a manager was in 1978 in West Haven and his summers have been filled with a spot in a Yankee dugout since. He has had more than 1,350 wins during his career in the minors, finishing first eight times and second six times. He even managed the New York Yankees during parts of the 1990 and 1991 season, accumulating a 120-155 record.

Derek Jeter had not played in a professional game since he injured himself during the Yankees' opening weekend against the Toronto Blue Jays. Prior to batting practice on May 11, 2003, he chats with Thunder manager Stump Merrill as he waits his turn in the batting cage.

The Thunder have been fortunate to host a number of major-league players during their rehabilitation assignments, but none drew more attention than Yankees shortstop Derek Jeter. The fans at Waterfront Park line up to get a glimpse of the shortstop as he prepares to rehabilitate his left shoulder during the second weekend in May.

Although his throwing arm was not injured in the collision with Ken Huckaby of the Blue Jays, swinging a bat was the concern for Jeter and the Yankees. As he prepares to get into the cage, the preparation for live game action had to feel good. At this point, Jeter had already met with the 200 or so members of the media who came by to watch.

Jeter's rehabilitation in Trenton lasted five days, but his impact on the fans and the current members of the Thunder will be lasting. In five games, Jeter hit .444 and made several outstanding plays in the field. By the time he left to rejoin his teammates in New York, his injured shoulder was close to 100 percent. The impact of Jeter's arrival was felt in many ways during his stay in Trenton. For the players, he rubbed off some of his World Series experience on them. For the fans, it gave them a close glimpse of a star player. Those fans came in droves to see Jeter. In his five games with the Thunder, the franchise drew more than 40,000 fans, which included a franchise record 8,729 fans on May 10, 2003.

The success of Derek Jeter led to the Yankees sending pitcher Jose Contreras and Bernie Williams to Trenton for rehabilitation. Williams appeared in five games for the Thunder on his way back to the big leagues in July 2003. During the five games, Williams played center field and was also the team's designated hitter. He hit .333, with five hits and four RBIs. Two of the hits were doubles. Williams also helped bring in the fans.

The Double-A Association decided to do away with its collective mid-summer game, so the Eastern League decided to have one in 2003. David Shepherd, who won six games in the first half of the season and garnered an ERA of under 2.00 with 39 strikeouts, was one of three Thunder players to play in the game.

Selected in the fifth round of the 2000 draft out of Vanderbilt, left-hander Andy Beal finished the first half of the Thunder season with a 3-0 record for Stump Merrill's squad. He did not allow a home run in 12 appearances and had 41 strikeouts in 43.2 innings of work.

Infielder Andy Cannizaro was in his third season of professional baseball when he donned a Thunder uniform. The native of New Orleans was hitting close to .280 when the first half of the season came to a close. He had 16 doubles and split his time between second base and shortstop.

A member of the 2001 New York-Penn League All-Star Team and the league's MVP while playing in Staten Island, Aaron Rifkin has made the transition from California State University at Fullerton to the professional ranks with relative ease. The first baseman finished the first half of the 2003 season with double-digit home-run totals, as well as 29 extra base hits. He also joined a long list of Thunder hitters with two home runs in a game on June 9, 2003, when Trenton defeated Erie.

Making his second appearance at the Double-A level, Myrow hit .303 in the Eastern League in 2002 with Norwich and had 3 home runs. The free agent from Louisiana Tech surpassed his two-year combined total of home runs (11) in the first half of the 2003 season. Not only did he finish the first half of the season among the league leaders in home runs, but he also finished in the Top 10 in RBI. Myrow was one of three all-stars for the Thunder in 2003.

Since he was selected in the seventh round of the 2000 draft out of Arizona State University, outfielder Mitch Jones had put up good power numbers. He hit 11 home runs in his first season of professional ball, but then followed that up with 21 home runs in 2001 and 23 combined home runs in 2002 at the Single-A and Double-A levels. At the midway point of the 2003 season, Jones had already connected on 13 home runs and 58 RBIs. He had 70 RBIs in 2001 and 2002 and was on his way to that number in 2003.

One of the many Asian players to dawn a Thunder uniform, Chien-Ming Wang signed with the Yankees out of Taiwan in May 2000. A member of the Chinese Olympic team, 2003 marked his first season in Double-A baseball. By the all-star break, Wang had won four games and had an ERA of 4.37. Wang, along with teammate Dave Shepherd and Andy Cannizaro, represented the Thunder in the Eastern League All-Star Game.

The 2003 Thunder yearbook depicts the 10-year anniversary of the club and includes cover photographs of the different people who have made the Thunder experience so special.

There were admitted naysayers when the thought of minor-league baseball returning to Trenton started to surface in 1993, but those individuals have since turned into believers after 10 successful seasons along the banks of the Delaware. When Jim Maloney and Joe Finley visited minor-league games in Reading during the early 1990s, they probably never envisioned the success the team has enjoyed over its first decade. Maloney passed away after the 1994 season and never saw, in person, his dream hit its pinnacle in 1998, when the team drew 457,344 fans. The dream remains alive and the 2003 campaign, which was enhanced by the appearances of Derek Jeter and Bernie Williams, was a clear indication of how strong that dream is when the four millionth fan walked through the gates of Waterfront Park on June 25, 2003. This photograph is of the Derek Jeter's final day at Waterfront Park.